D1288481

Myth and Landscape David Parker

Myth and Landscape

David Parker

KEHRER

To dear Roger —
In great appreciation
of your marvellous work,

Marina Warner

29 May 2015

Then all at once the wind fell, and a calm came over all of the sea, as though some power lulled the swell.

Homer, The Odyssey

Sirens

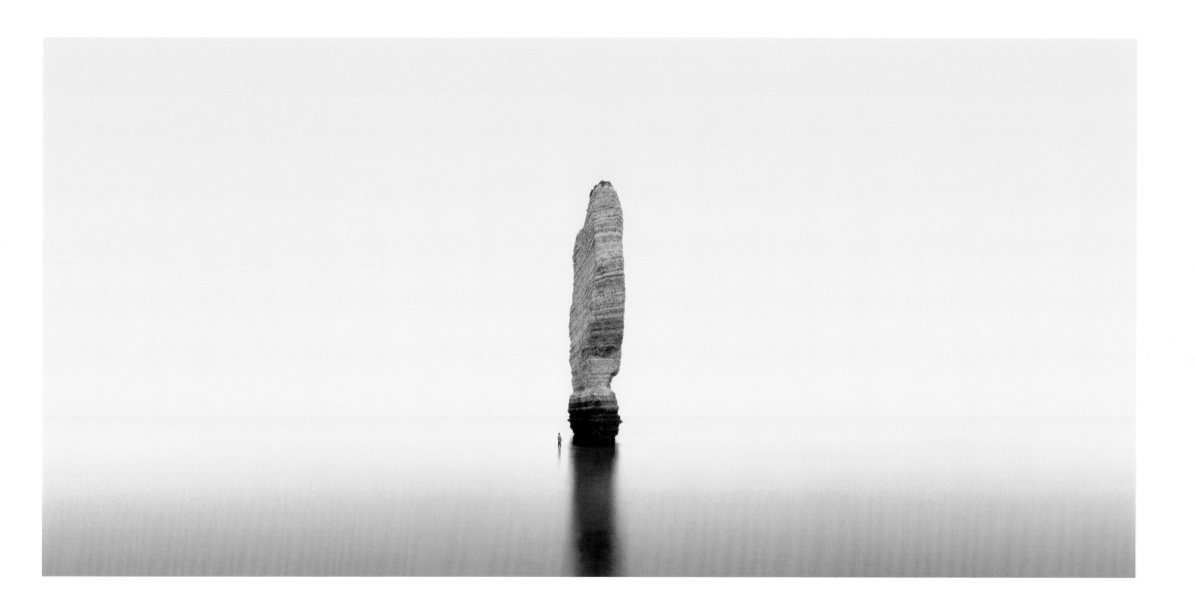

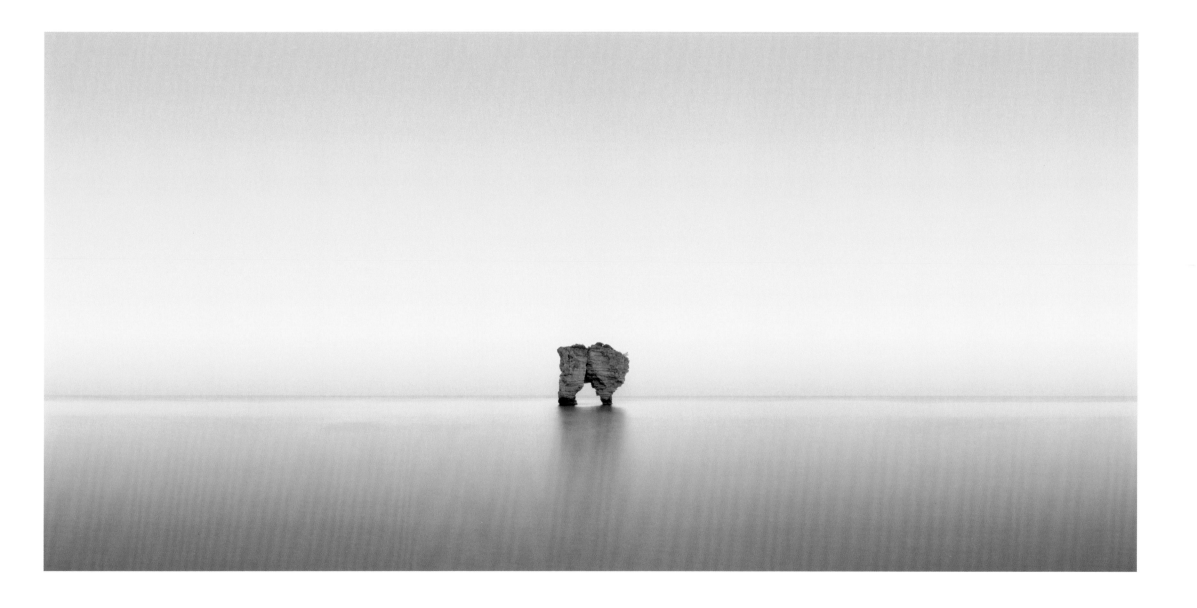

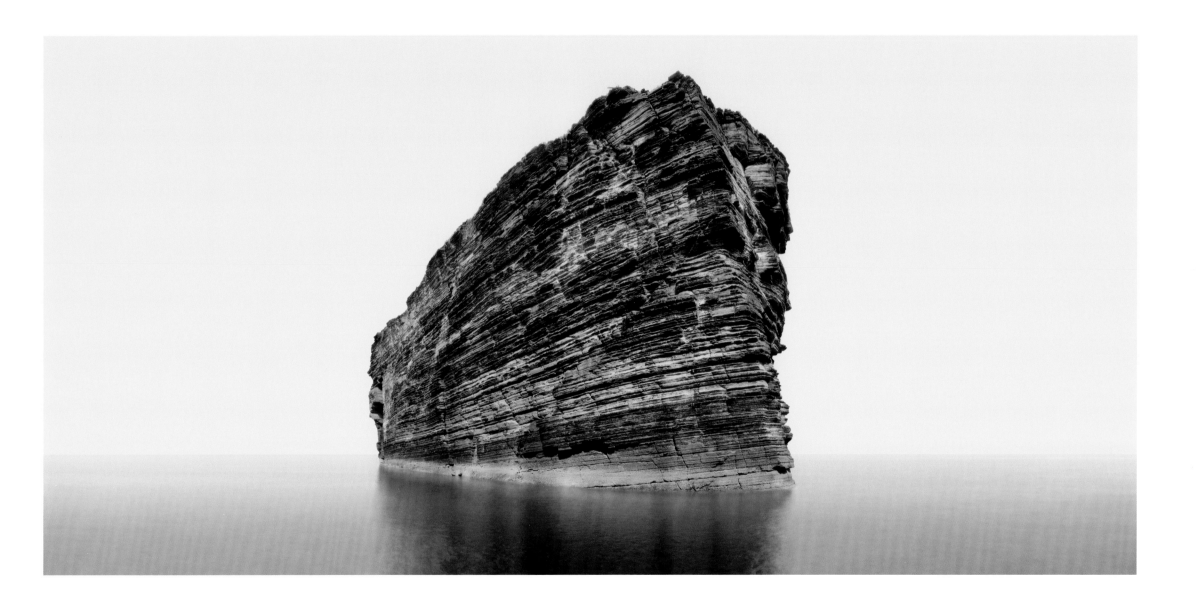

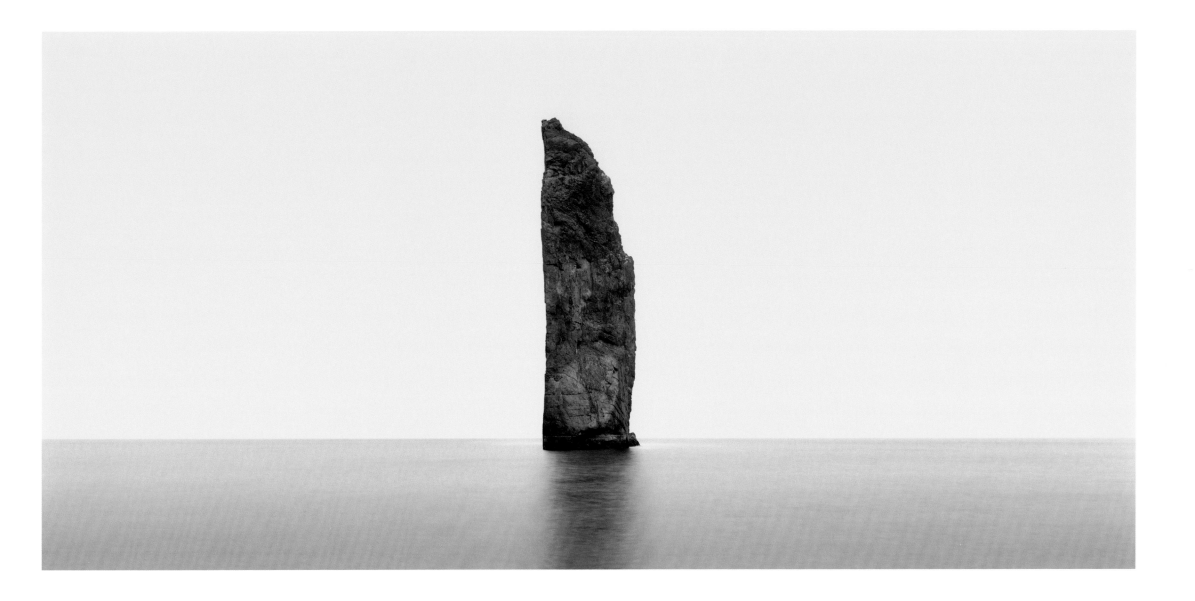

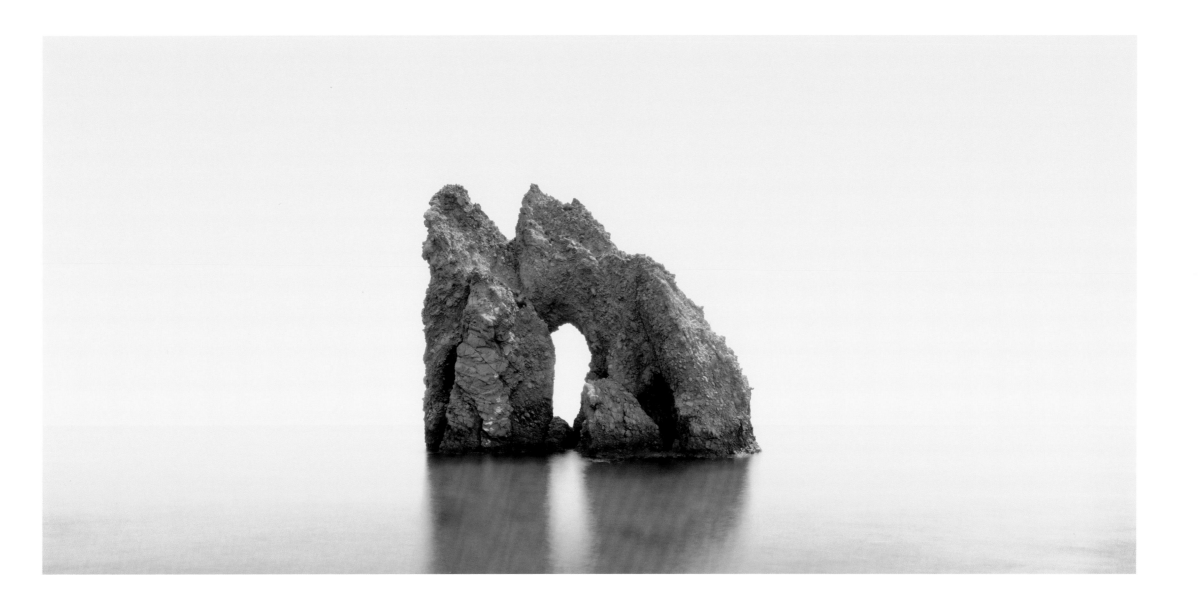

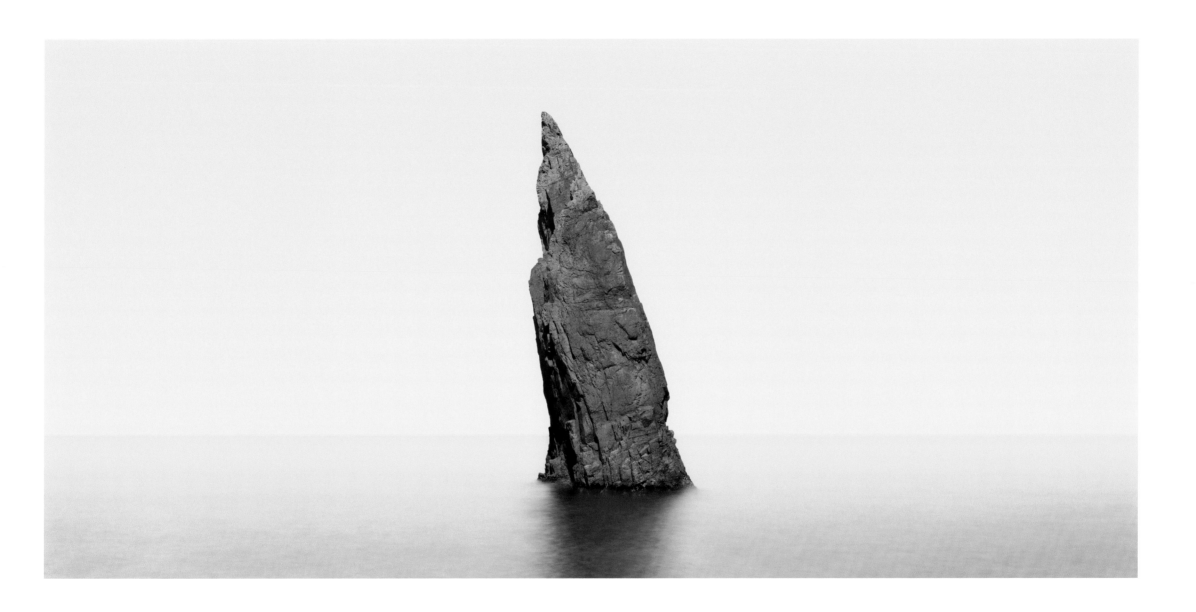

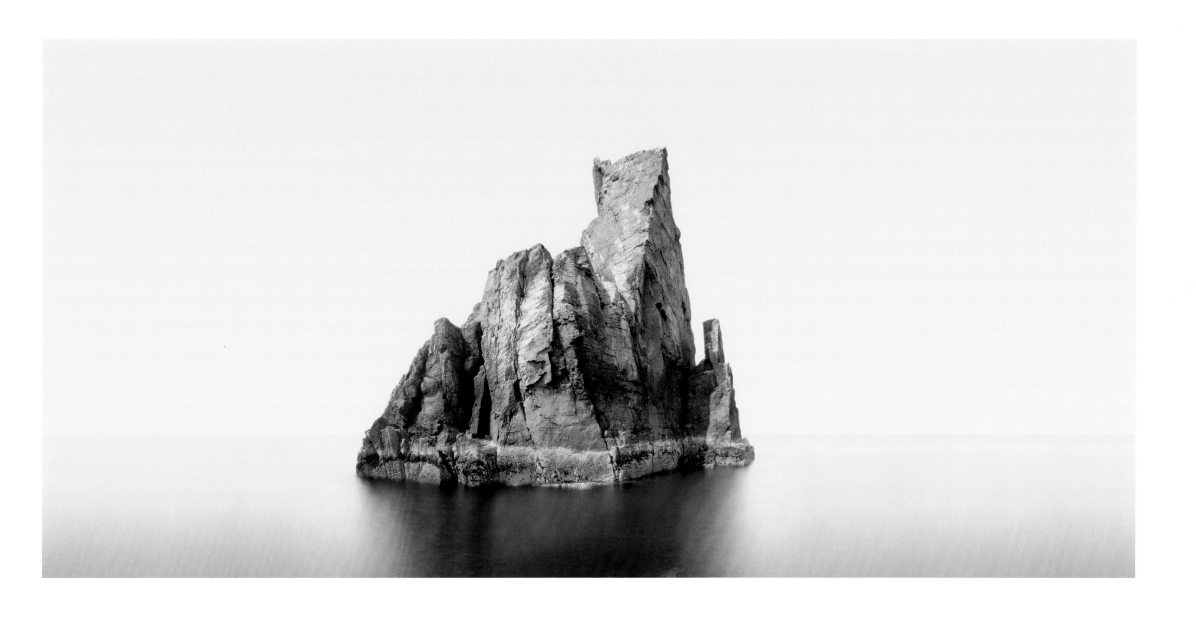

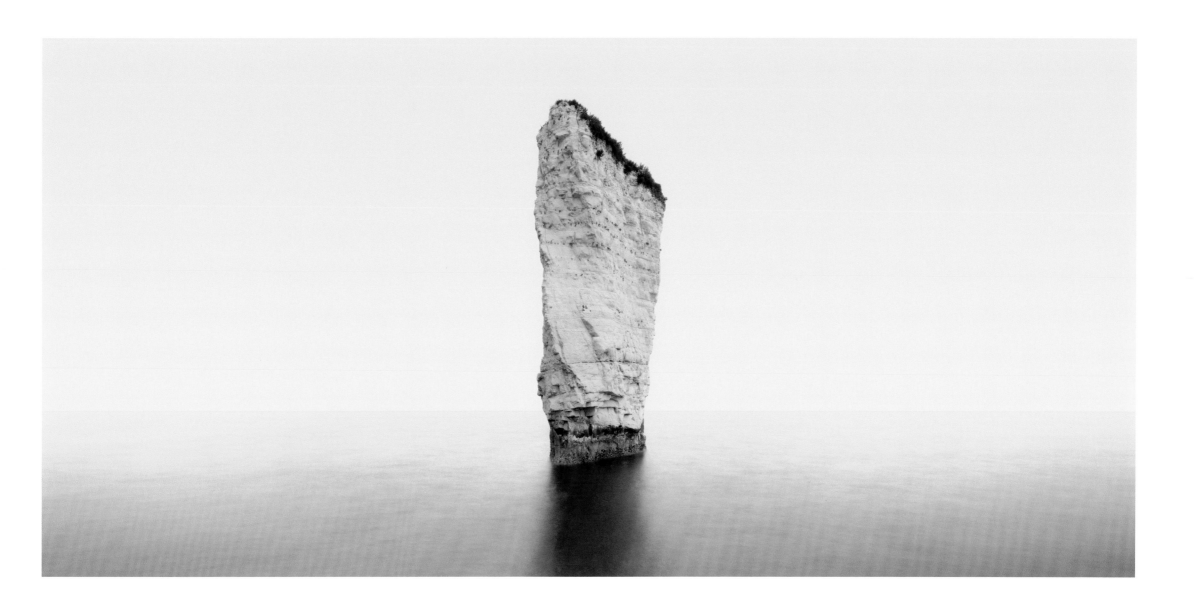

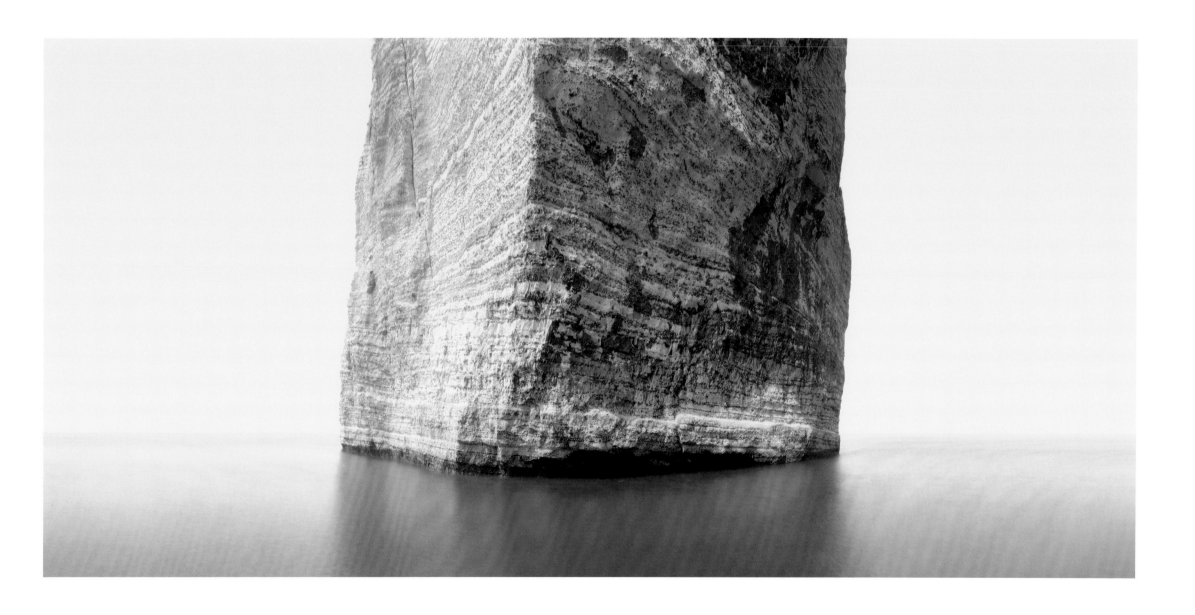

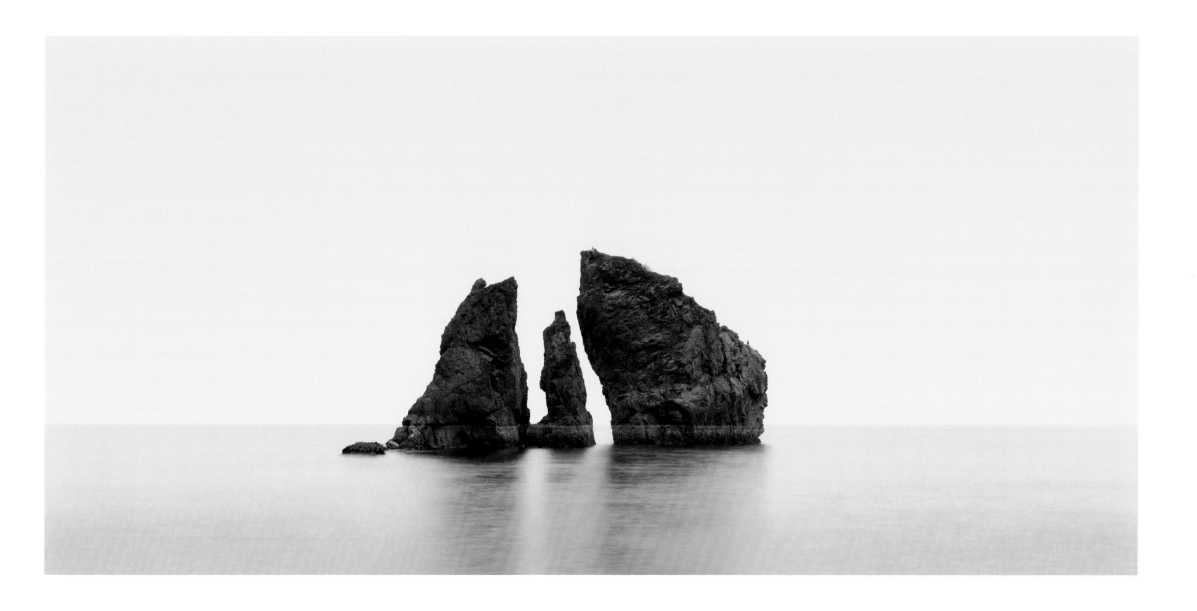

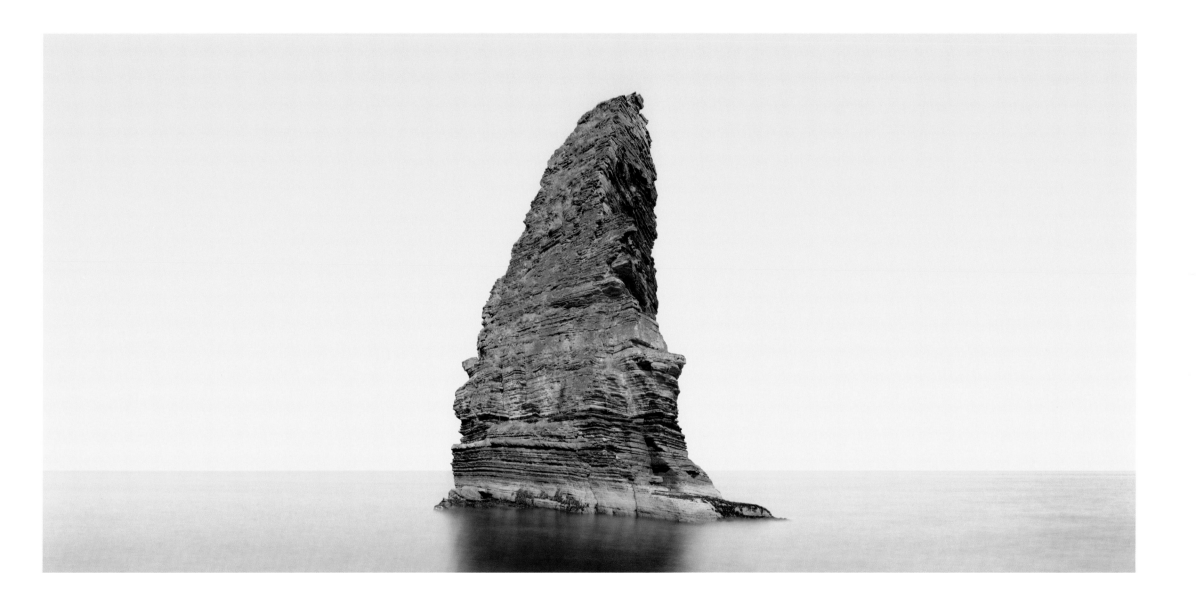

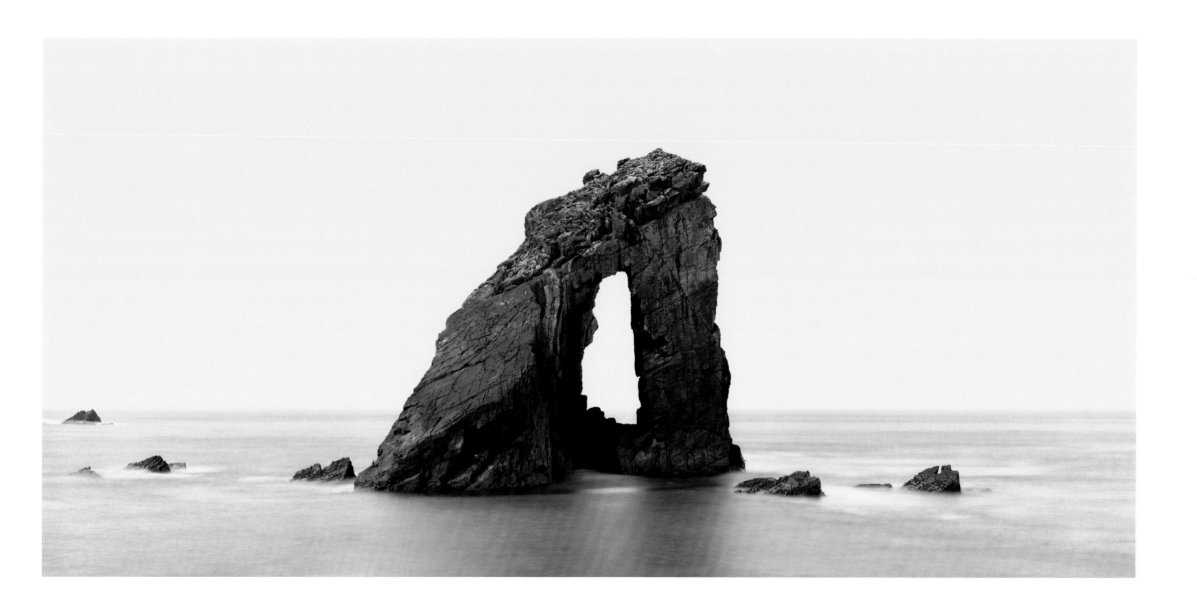

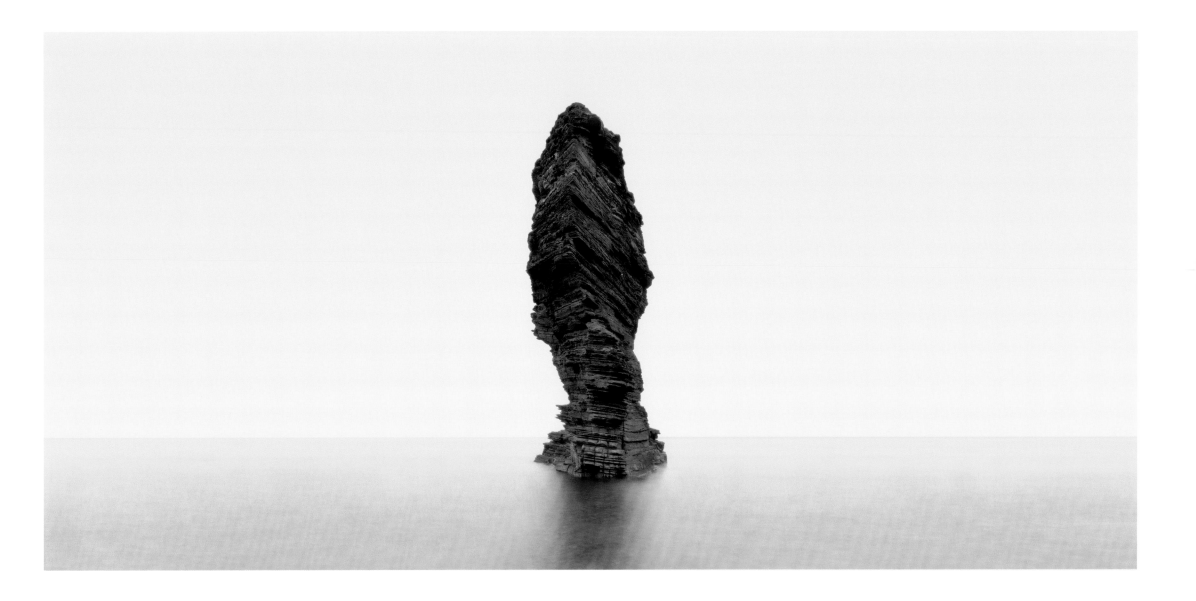

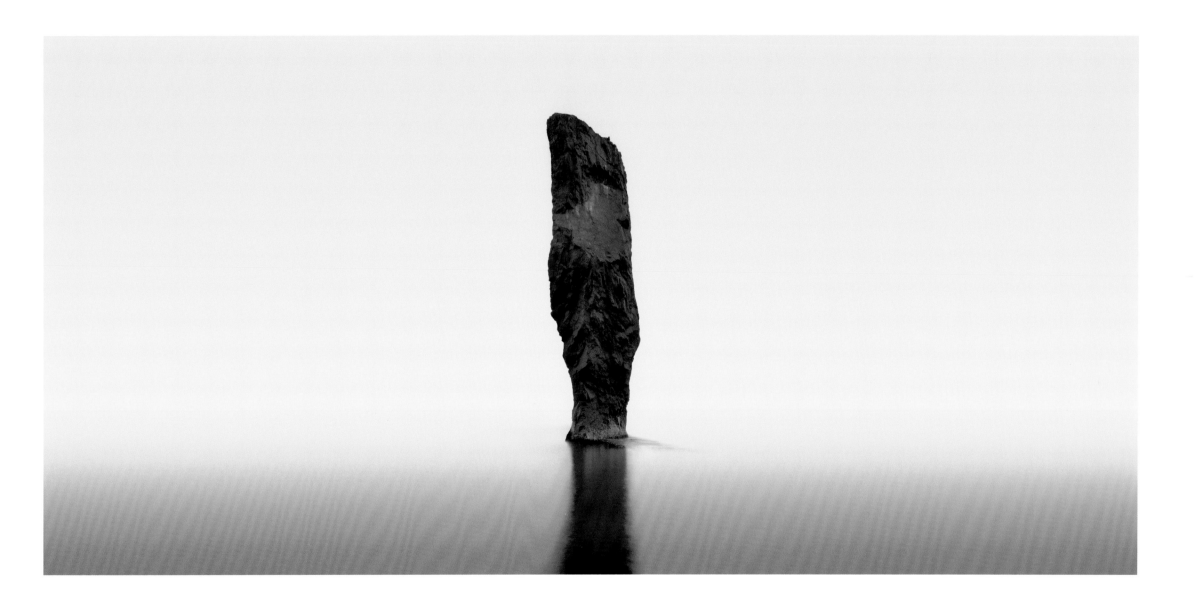

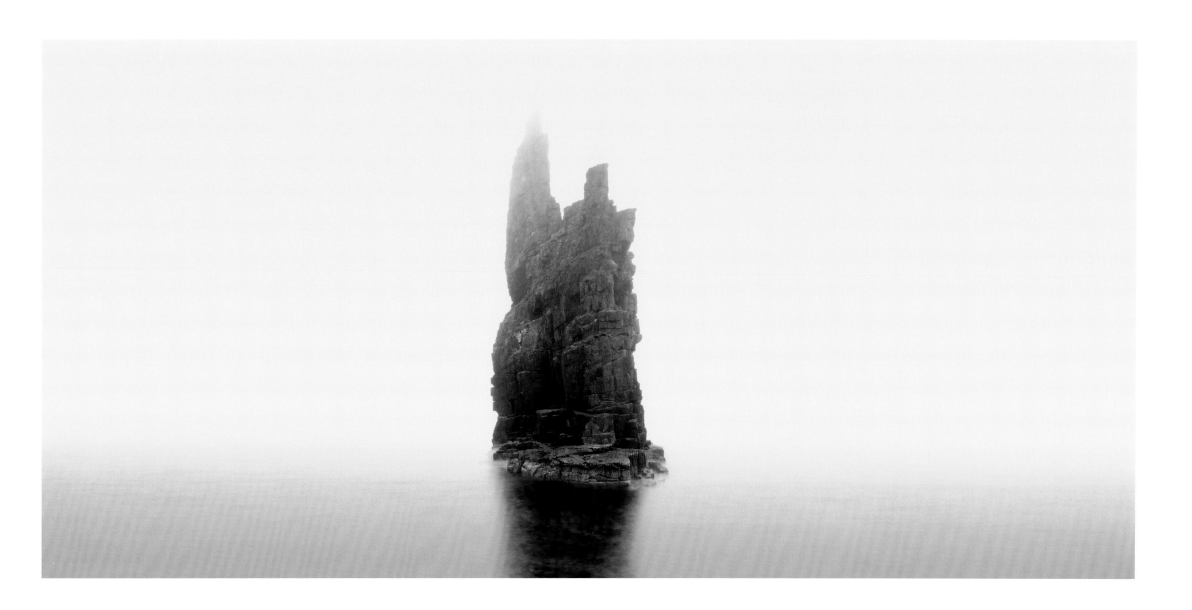

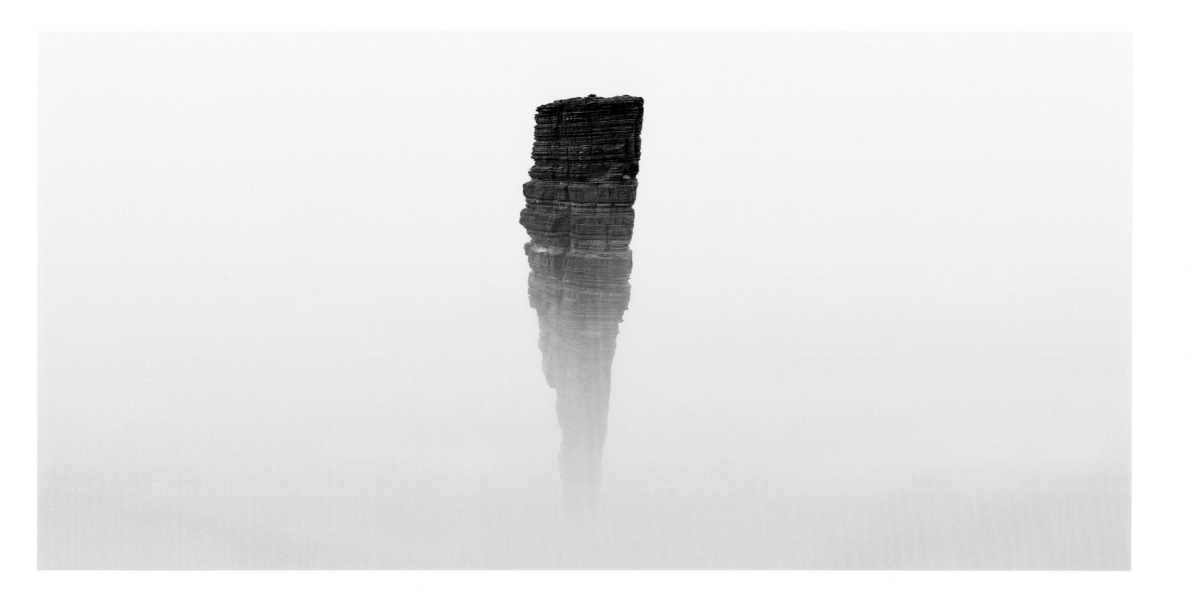

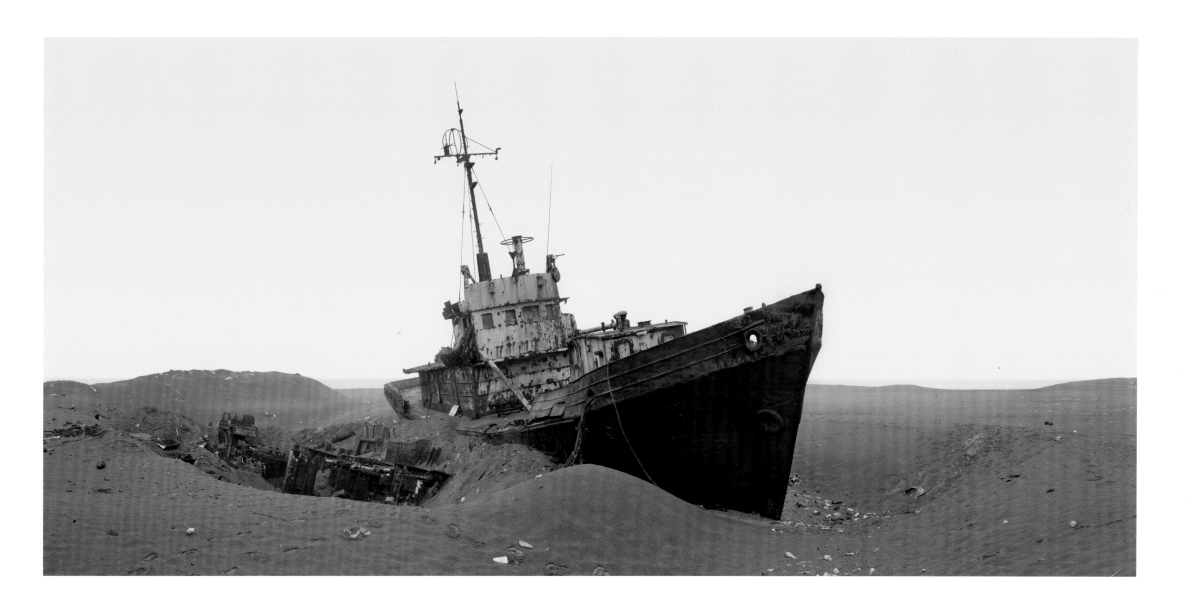

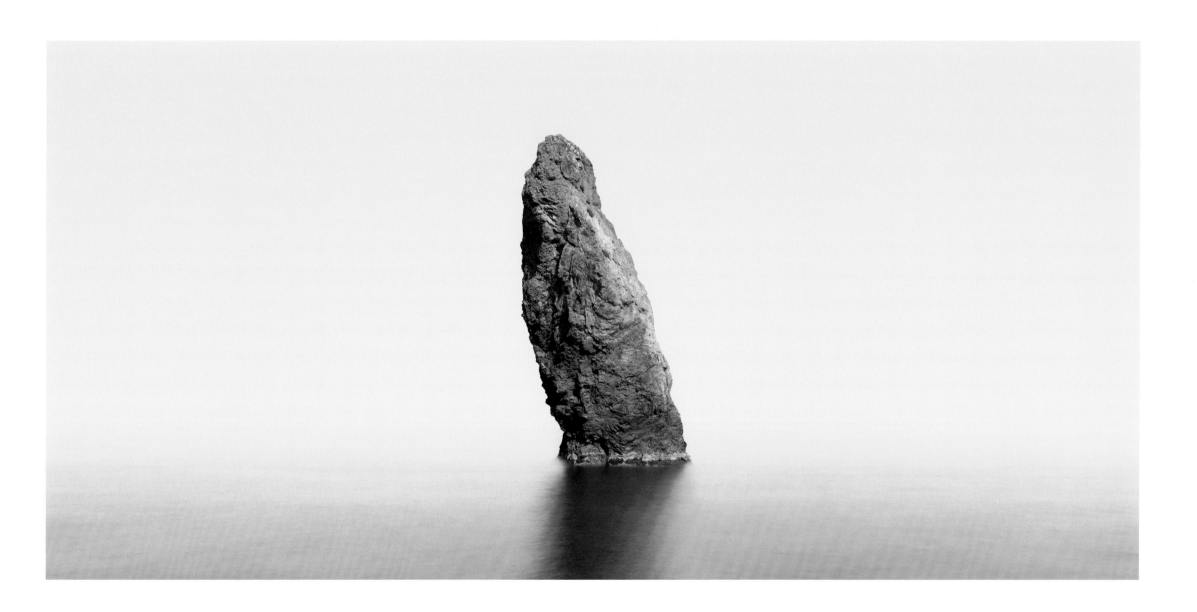

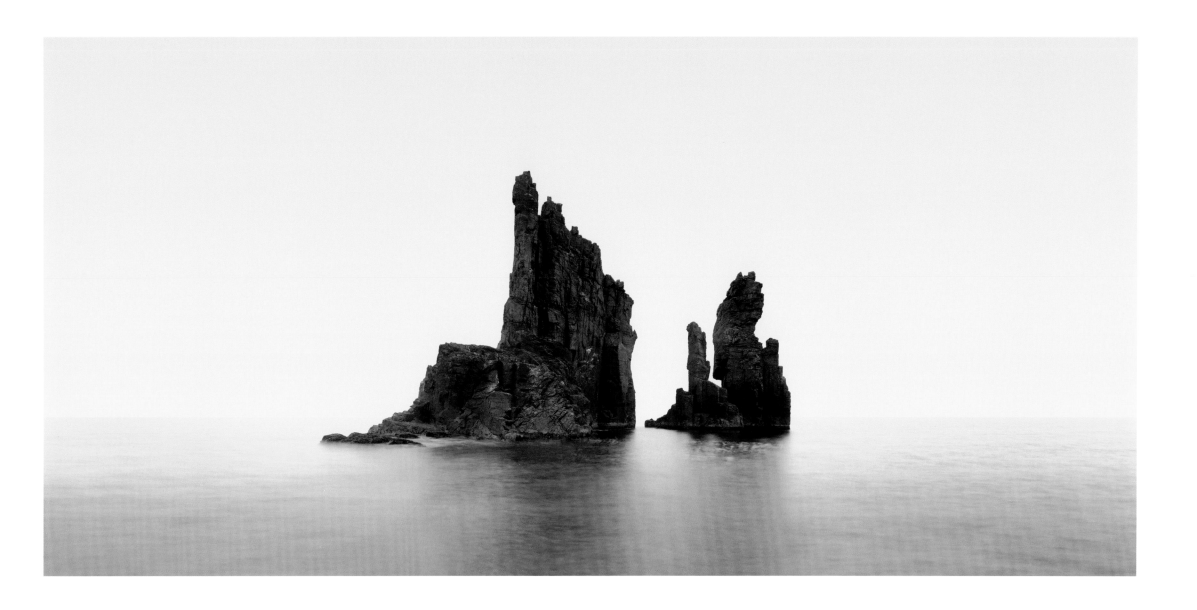

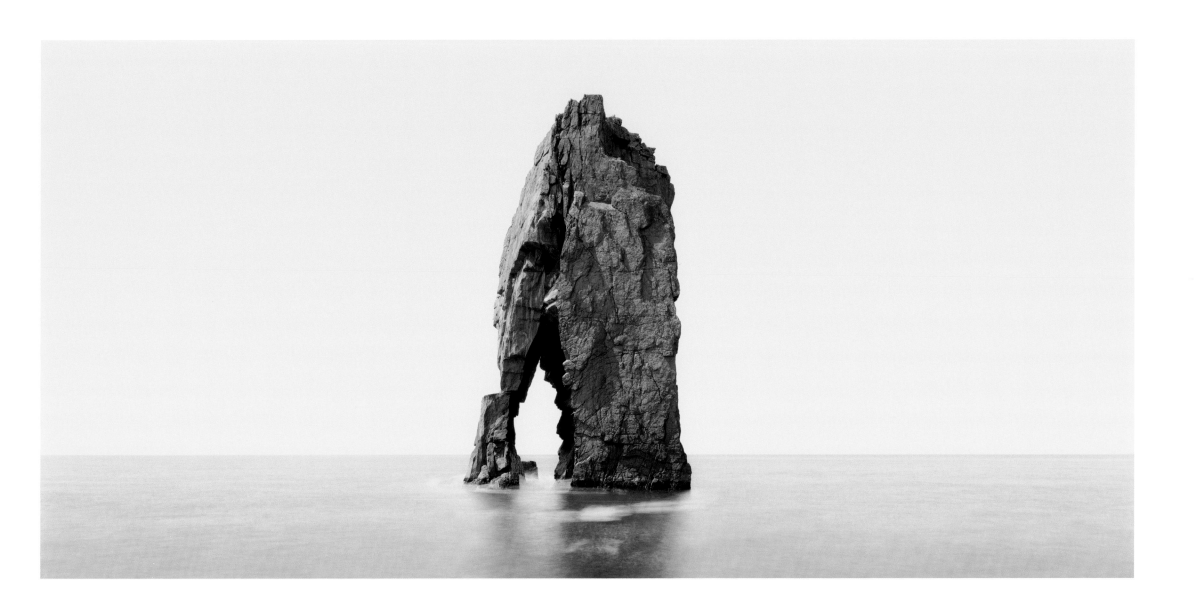

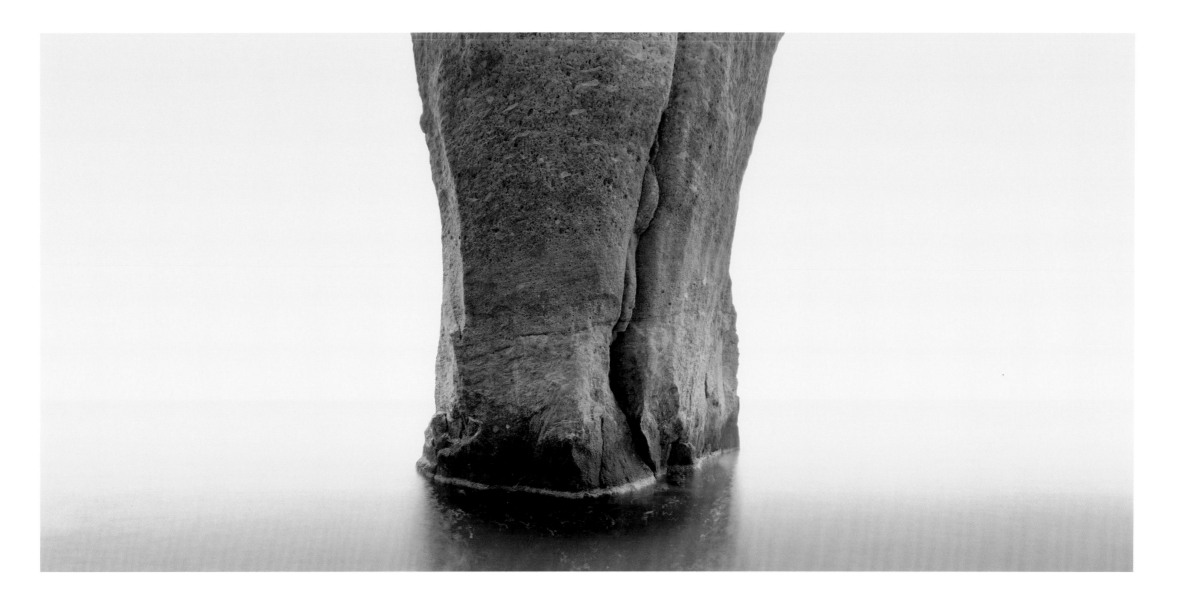

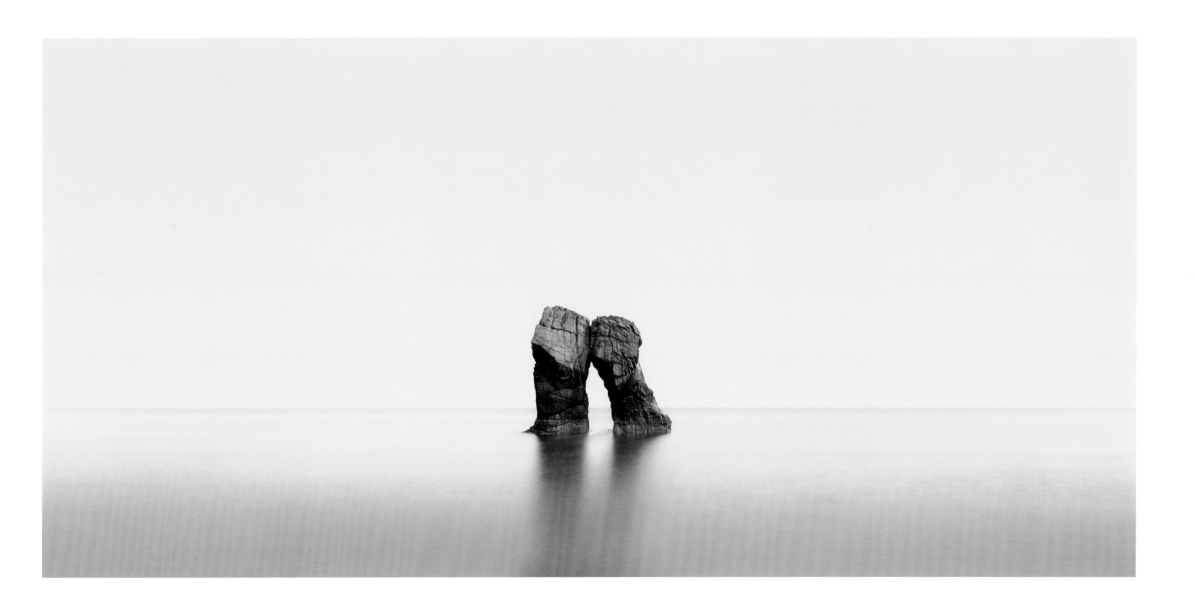

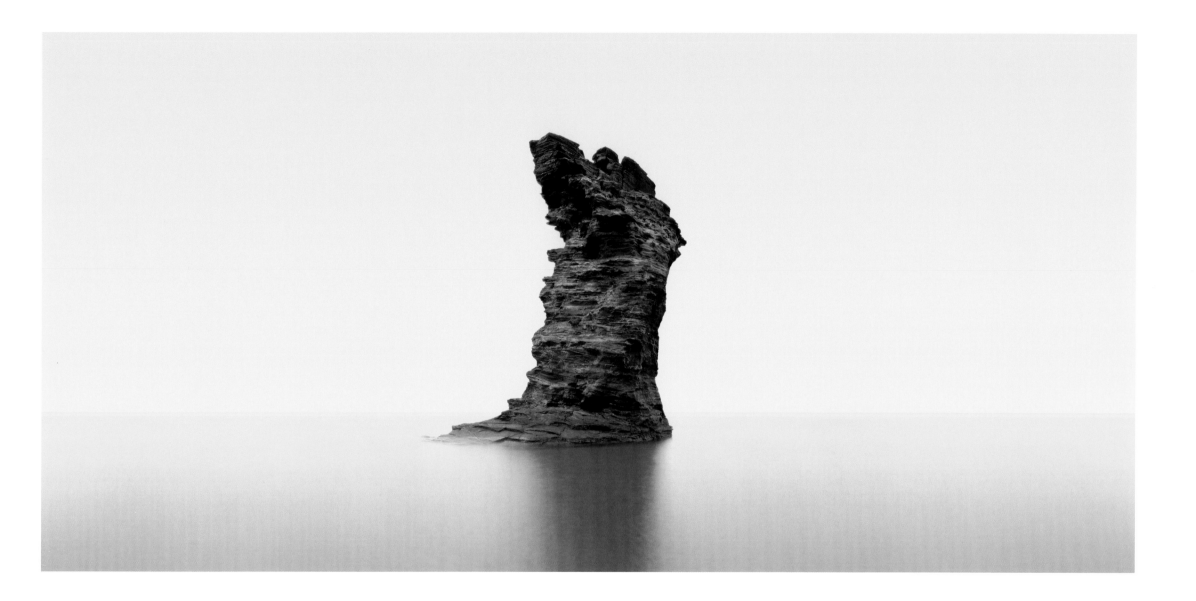

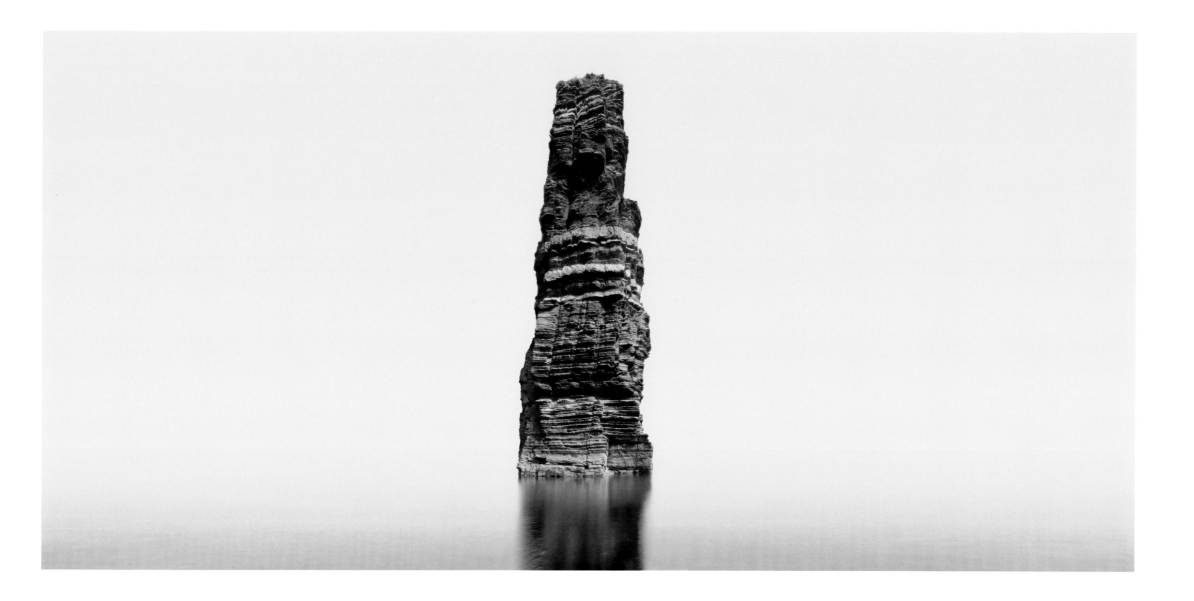

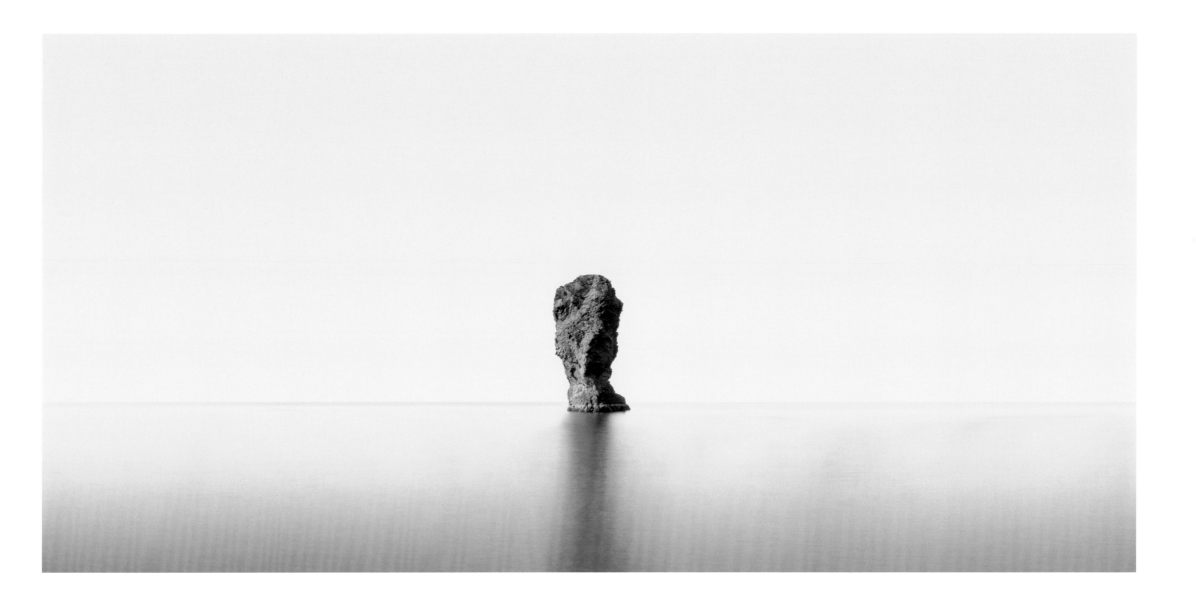

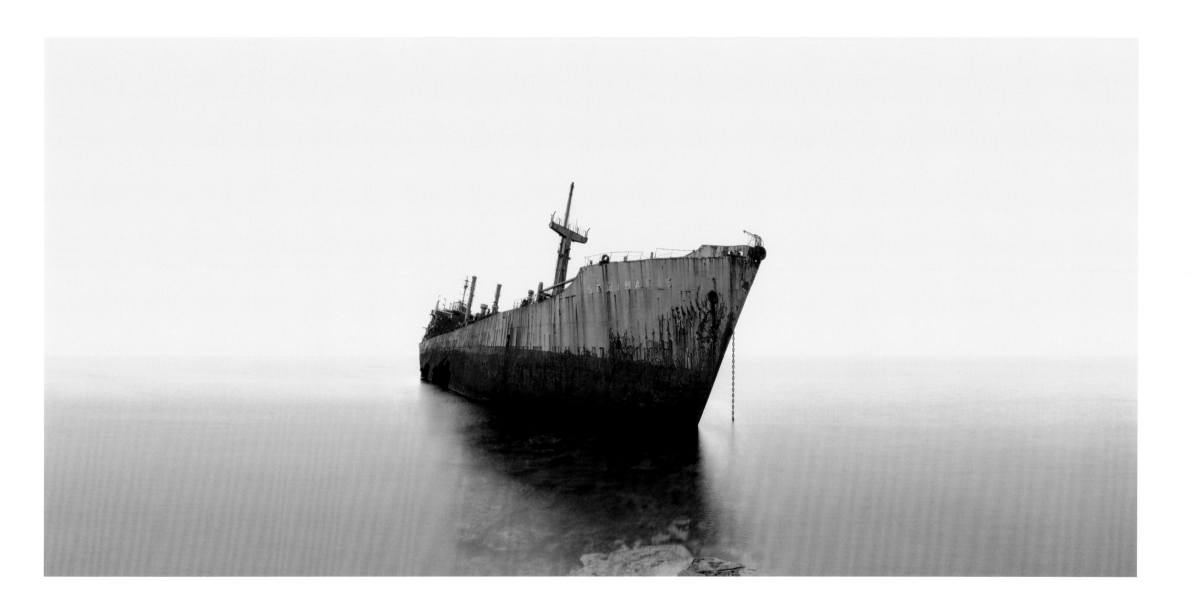

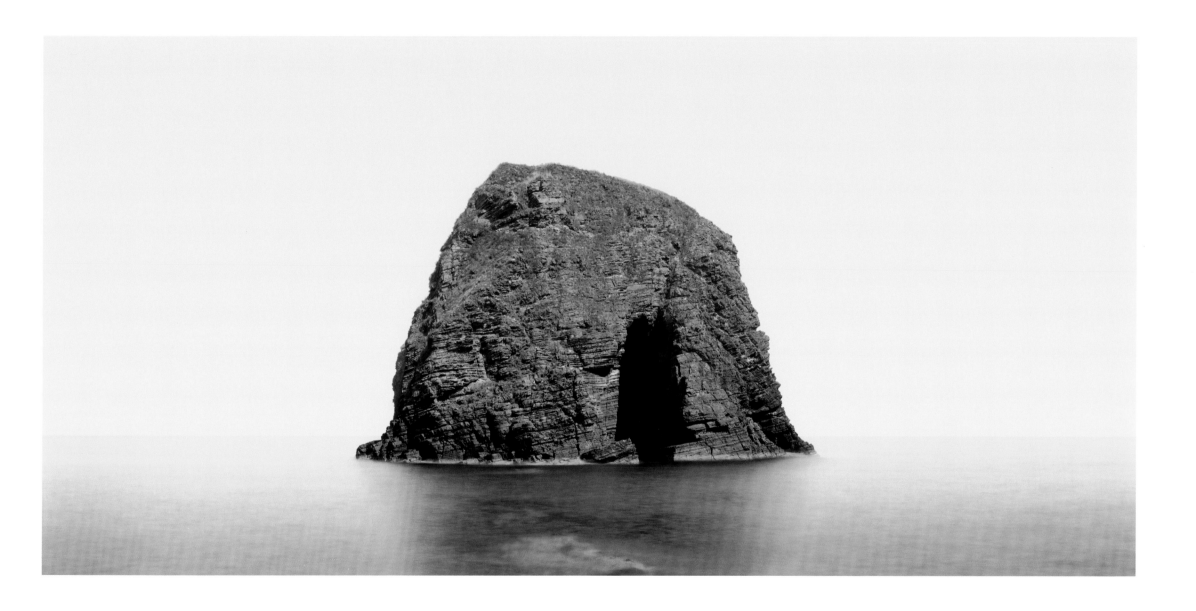

Singing Each to Each
Marina Warner

Now the sirens have a still more fatal weapon than their song, namely their silence.
And though admittedly such a thing has never happened, still it is conceivable that someone
might possibly have escaped from their singing; but from their silence certainly never.

Franz Kafka, 'The Silence of the Sirens'[1]

I

In the *Odyssey,* Homer's sirens lure their prey with promises of glory and knowledge, from a meadow by the shore where the bones of their victims lie scattered and bleached among the flowers. Nowhere do the classical poets suggest sirens have cannibal tendencies — not like the harpies or monstrous Scylla with her girdle of ferocious dogs who fishes for sailors not far from the sirens' island, and to whom Odysseus will have to sacrifice six of his men. The sirens are fatal to humans because Homer, like so much Greek thought, prescribed limits on human ambitions, and through Circe he warns that the hunger for experience can never be satisfied, for it will always outdistance human striving. Cicero differed; he described the sirens' song as the call to wisdom. Sex is part of that wisdom, but not all of it.

Odysseus heard the sirens' song and does not tell us what they sang. A vase painting, made two centuries after Homer, shows the sirens as bird-bodied, with women's faces, swooping around the hero's boat; as birds, they have sweet honeyed voices, like *apsaras* in Indian mythology, who also enthrall their victims making music on the wing. In Homer's epic, Odysseus writhed in his bonds to rush to them, or so he tells the company in Alcinous' palace, but his men obediently kept to their stroke, deafened by the beeswax he'd stopped their ears with. Maybe he was boasting and never heard the sirens at all; this is what Kafka suggests when his Ulysses plugs his own ears, and then imagines their song — and so escapes the far more deadly danger, that the sirens have no song to sing.

David Parker has embodied the silence of the sirens. His photographs, taken on sea voyages in places that he chooses not to name, summon lone rocks, arches, needles and spars floating in an eerie, still isolation as they loom against a luminous horizon; his seas look poured like smoked glass from edge to edge and beyond. He endows them with sculptural qualities: colossal Giacometti figures of shadow and suggestion, natural Brancusis, rough-hewn or smoothed by the impact of the elements.

Homer describes how, when the ship of Odysseus approached the shore of the sirens' island the waters became still; the sea stretched out on all sides taut and smooth like a tympanum so that the sound of their singing could float out without distortion across the water and lure passing sailors. Maybe, some commentators believe, the sirens of classical mythology figure such becalmed days at sea when not a breath stirs and the heat wraps sailors in feverish dreams, as Coleridge evokes in *The Rime of the Ancient Mariner:*

Down dropt the breeze, the sails dropt down…
Day after day, day after day,
We stuck, nor breath nor motion;
As idle as a painted ship
Upon a painted ocean.[2]

When nature stills into art in this spellbound way, space turns into timelessness and the borderless view into a suspended moment that is forever now and yet never was anything but eternity. This state, which holds flux in thrall and dissolves perspective, has been achieved by technical artistry, both in the customized use of the panoramic camera itself and in the darkroom: David Parker uses a deep blue filter so that the camera sees above all the blue band of the spectrum, for it is blue, the colour of the sky and the sea, that in a monochrome print still vibrates with the depths of space and time.[3] He dilates the temporal feel of his images by exposing over lengthy

periods, photographing through the kind of slitted lens used for recording race-horses crossing the finishing line. And his subjects — the rocks he calls sirens — are themselves witnesses to time's work; they remain from land masses that have disappeared; in the form of arches and cairns, sea-stacks and caves, they partake of the romance of ruins, presenting a cryptic rubble of the past. But nostalgia does not fit the feelings they inspire (though Odysseus was the original nostalgic, struggling to find the way back to Ithaca, the original place of homecoming). David Parker's Sirens make one turn the mind inwards rather than retrospectively; the suspended moment of the glassy sea, the mysterious solitude of the pillars and the caverns with their dark openings invite dreaming about what they might be and what secrets they guard, rather that what they once were; as sentinels and markers they point the way — somewhere — signaling enigmas in their keeping and marking points on an inscrutable map.

Muteness: eloquence's reverse face. This condition returns as a crucial theme in tales of mermaids inspired by northern European legends about sea sprites or undines, and reaching its most popular and definitive form in 'The Little Mermaid' by Hans Christian Andersen, in which the heroine gives up her sweet singing in exchange for existence as a woman in the world above, beyond her native element the sea. The scene when the little mermaid makes the fatal bargain with the sea witch, who takes her voice in return for giving her a human body, was reprised even more cruelly by Jaroslav Kvapil, the librettist of Dvorak's opera *Rusalka* (1901) — *rusalka* being Czech and Russian for a mermaid or sea nymph. In this work, the heroine Rusalka also accepts silence in return for human existence and union with the prince who has inspired her to love. But in an opera, to do this, to forfeit the power to sing! — Nothing could convey more sharply the self-abnegation of the heroine than the soprano lead turning mute.

This cycle of fairy tales intuits the deep fatefulness that swells the undertow of the siren myth. Many of them invoke treachery in love — or lust. But at a deeper level they pull us towards understanding that between the imagining and its image, between the thing held in the mind and the thing in the world, a breach will open; there will always fall a silence. When a siren or a mermaid steps into the world, something of her must fade.

II
Yet this is not the full effect of the siren's silent presence. Here Kafka, in his enigmatic fable of 1917, suggests another meaning: that their unheard music, sweeter by far, extends towards us a promise that significance will emerge in relation to our being there to hear it, when we hear it, if we hear it.[4] Imagining the song, we find a way of existing in relation to what we see.

In the Mediterranean, especially in southern Sicily and the coast of North Africa, when the high heat of summer steams mist over the sea and binds it into a motionless and glassy lake, a rare mirage sometimes occurs: the legend used to say that Morgan Le Fay lived under the sea and raised phantom palaces and gardens as illusions in the sky to divert the lovers whom she had captured and enticed to live with her. David Parker's sirens aren't Fata Morganas, those shimmering castles in the air or in the depths on the dog days, but they play to the imagination in a similar way. When we cannot hear their song, we imagine we catch some of its notes all the same.

Living near a landmark in the sea inspires stories; many have names — the Dodman, the Needles, the Old Man, the Fitt… Willie Sinclair, a crofter-fisherman on the Caithness coast of Scotland, the last independently working those waters in the old style, was able to give such detail of every gnarl, knob, and boulder, inlet and fissure, stack and gully, rock and cove of the coastline so vividly that an accurate map was drawn from his descriptions.[5] This is, perhaps, an incomparable way of knowing what the sirens sing, to have such intimacy with the matter of the world. This fisherman remembered the land and the sea as extensions of his own body and of his own time in his body rather than a single mental event, or a map on a two-dimensional plane.

David Parker prefers to leave his subjects nameless. Still, they invite the viewer to drift over their hollows and bumps for features, finding features and faces in them ranging from the sublime and heroic to the tender and absurd. A craggy philosopher's brow appears in one teetering cairn, a tapered dancer in another, two giant heads lean in towards one an-other and seem to nuzzle and kiss; one jagged pile stretches out a crooked limb like a crab of stone, as in so many stories about living beings petrified into rock through the natural processes evoked so richly in Ovid's *Metamorphoses*. From Homer onwards, the classical heroes circumnavigate dangers embodied in cliffs and mountains, whirlpools and marine wonders that memorialize the figures of giants and other monsters. The word Gryphon, for a certain type of hybrid monster, is even related to the word for riddle or enigma, *gryph,* while the Sphinx, another mysterious creature now metamorphosed into stone, set her fatal riddle to wayfarers — until Oedipus passed and solved it.

The natural cycle of generation inspired numerous myths in which flesh turns to stone and vice versa: during the aftermath of the Flood, the only survivors Deucalion and Pyrrha (the classical Noah and his wife) consult the oracle of the Goddess Themis about what they should do in all this desolation, and the answer comes, 'Throw your mother's bones behind you!'[6] At first baffled, Deucalion at length realizes that the oracle must mean Mother Earth, and begins, with Pyrrha, to pick up boulders from the ground; as they walk, the stones they strew behind them spring up into new human beings – women from Pyrrha's, men from Deucalion's. By contrast, in other stories of metamorphosis, stoniness spells the eternity of death: Perseus, brandishing the head of Medusa, turns the brawling Phineus and his riotous companions to statues of stone; Niobe is cruelly punished for boasting about her children when each of them is struck down one after another, all fourteen of them, by the arrows of Phoebus Apollo and Diana. The grief freezes Niobe, her 'vitals hardened / To rock…To this day the marble trickles with tears.'[7]

These fancies breathe in David Parker's photographs, which keep the atmosphere of imposing, perilous, sphinx-like presences; and as we attribute stories and personalities to them, we taste the phantasmagoric pleasures of the mirage. The sequence of becalmed rocks thus belongs in the enigmatic tradition of the sirens: illusions spring from these intense stones and seem to hint at messages, as the cracks in a sheep's shoulder blade scribbled by a heated tool presented an oracle to the ancient Chinese soothsayer. The practice of cloud-gazing to discover shapes of giants and dragons is described in antiquity; Leonardo recommended inventing new compositions through daydreaming before 'images made by chance' — by stains on the wall and clouds and smoke and other confused and featureless things. Max Ernst found Eve in the wood grain and knots of the floorboards, and the artist Paul Nash, photographing blasted trees in Romney Marsh, identified Laocoon writhing there and a 'personage' with a cloak billowing behind.[8] This kind of imaginative projection, once the method of state diviners and scryers, received a different form of official approval in the Twenties, when the Swiss psychologist Hermann Rorschach introduced his famous set of test cards made from random blots, folded over to create symmetrical branching shapes which he then asked patients to contemplate and interpret. Reading the haphazard patterns of tea leaves or coffee ground or broken egg yolks, a fortune teller presented a picture of the future for someone who had come to consult her; Rorschach reversed the direction and, as diagnostician, asked his subjects to offer the interpretation themselves, which he then read and analyzed. His method entered medical practice and has remained in use in the United States, though coming under increasing criticism. Cognitive psychology, as it commands ever greater popular interest (numerous studies of the brain and of consciousness load booksellers' shelves), has however brought a sharper awareness of the vagaries of fantasy in the ways we see objects in the world, spread a wider understanding of the frequency of illusion and delusion, and drawn attention to the brain's propensity to see what it expects to see and to supply what is lacking. A natural phenomenon casts its own scintillating and dancing light on the story of the self, as the phenomenon changes character, shedding the divine portent to become a psychological mirror of the viewer's mind, and a surrealist *foyer de songe,* a hearth for incubating inner fantasies.[9]

Non-sense is very engaging, but the mind strains to make it make sense. In psychology, a new word has been coined to describe the practice: pareidolia means seeing faces in random marks, or other significant forms where there none have been placed. The tendency, marked in young children, who will fear a shadowy shape gathering in the curtains or a monster face grinning in the fabric itself, occurs in adults suffering from fevers or mental trouble, when inanimate objects will seem to be menacingly alive and mocking them, or worse. It still brings about religious prodigies: visions of the Virgin Mary in broken snow or clouds, the devil's profile over the World Trade Center just before 9/11, and the name of Allah inscribed in an aubergine. Modernists and abstract expressionists jeered at this child-like or psychotic faculty — there is a story about Isamu Noguchi reproaching Arshile Gorki for seeing faces in the clouds — but in recent decades there has been a strong new interest in the phenomenon, setting mockery aside: the imagination's inbuilt capacity to make things appear on its interior screen seems existentially crucial, and worth more attention than a glib dismissal.

III
The reciprocal exchange between the image and its observer enacts the mystery of art's power to communicate: from the page words call to the reader, and pictures beckon from the page or the wall or the screen. You are not there when the words or the image were being made but they are addressing you, calling you to their presence and to respond: the

apparition summoned by a piece of writing or an image within its body summons "you" when it impresses itself on your mind, and the act of looking and reading brings my consciousness into play, and that helps form my sense of presence. The longing that the sirens stir can be desire for the other — as in love, as in sex. But when that other is so mysterious and unknown, the longing expresses a need to experience things intensely in order to feel alive. Love, desire, give this: Dante in his highly ambiguous dream of the Siren, recognizes her as a false and sinful seduction. But before he does so, he writes that under his dreaming gaze her tongue is set free and she colours 'com'amor vuol' — as love wishes — as she begins to sing.[10] Thus dreaming, Dante conjures her as a phantasm in the first place, and the love she then stirs in him (however deceptively) animates her and endows her with speech. Shakespeare in his Sonnets ceaselessly raises the object of his love by revolving the pronouns, Thou, You, I, and as we listen in, his lines tangle with the knots in our experiences of jealousy, rapture, passion, love's rewards and its discontents, and do not loosen them but illuminate their tensions and ambiguities. Theologians — most notably Martin Buber — have extended the model to describe divine love, and imagined God as the reciprocal answering voice, the words I and Thou sounding between God and human in a drama of prayer that guarantees the soul of an individual and so constitutes the self. John Berger invoked Buber when interpreting the mummy portraits from Fayum: the faces of the dead look out at us with their direct gaze, and constitute us across the centuries as their 'Thou' through the way their living likenesses silently voice 'I'.[11]

The enigma of the speaker in a work of literature or art — who remains invisible, absent, and unknown — reaches out to me, and seduces me as a reader or a viewer into feeling and stirs me into moving towards his — towards her — siren call. This is what the aesthetic order of reality can give us; as David Parker has written, the sirens figure art itself: 'The sirens' song… is also to my mind at least, the song of art, which charms and fascinates us into the ego-diminishing state of aesthetic enchantment, perhaps the goal and consolation of all art.'[12]

The poet Michael Symmons Roberts sees this as intrinsic to the mystery of consciousness itself:

You are on a mission to discover
why the human heart still slows
when divers break the surface,
why mermaids still swim in our dreams.[13]

The apparitions in the sea that David Parker has photographed hang in the air in this moment, a threshold between something dreamed and something real.

They throw their voices across the empty sea, and the song has never been heard, and never can be. But the sound stretches between us, between you, singing, and reaches me, now, listening.

[1] Trans. Willa and Edwin Muir, in *The Complete Short Stories of Franz Kafka*, ed. Nahum N. Glatzer (London, 1999), pp. 430–432.

[2] Samuel Taylor Coleridge, *The Rime of the Ancient Mariner*, intro. by Marina Warner (London, 2004), pp. 6–7.

[3] See above all William Gass's unsurpassed essay, *On Being Blue : A Philosophical Inquiry* (Manchester, 1979) for the manifold associations of this colour.

[4] See Piero Boitani, 'Ulysses, the Sirens, and the Pheasant', in *The Shadow of Ulysses:Figures of a Myth*, trans. Anita Weston (Oxford, 1994, pp. 164–188.

[5] Iain Sutherland, *Whaligoe and Its Steps: The Unique Harbour* (Glasgow, n.d.); 'Sarclet Head and Occumster', map by Iain Sutherland, by Willie Sinclair, from Whaligoe. I am grateful to Ian Macdonald for giving me this information.

[6] Ovid, *Metamorphoses*, trans. Rolfe Humphries (Bloomington, Indiana, 1983), Book 1 line 381.

[7] Medusa's story is told by Ovid, *Metamorphoses*, Book IV, lines 772–803 and the ferocious fight with Phineus and his men, in Book V, lines 1–236; Niobe's sad tale comes in Book VI, lines 312–317.

[8] See Tacita Dean, *An Aside*, South Bank Touring Exhibition, 2005.

[9] This is the phrase used by Roger Caillois in *La Pieuvre:Essai sur la logique de l'imaginaire* (Paris, 1973). For pareidolia and other cognitive illusions, see Marina Warner, *Phantasmagoria: Spirit Visions, Metaphors, and Media into the Twenty-First Century* (Oxford: Oxford University Press, 2006), pp. 94–117, 308–316.

[10] Dante, *Purgatorio* XIX, line 15.

[11] John Berger, *The Vertical Line*, Artangel event, London, 1999.

[12] Note to exhibition *Sirens*, Michael Hoppen Gallery, London, 15 September–31 October 2004; see also Malcolm Bull, 'The Ecstasy of Philistinism', *New Left Review* I/219, September–October 1996, pp. 22–41.

[13] Michael Symmons Roberts, 'Mapping the Genome' in Corpus (London, 2004), pp. 29–30.

Sea, water Desert; Desert, sand Sea
Ibrahim al-Koni

The Errant Twin
Ibrahim al-Koni

Al-Dunya en tasidert tkarras;
Wud esekin ar Idenan gbas.
Wissas Kud yara adu yaghlayas
Ed Kumbat sabada tekras follas.

World, you were created for patience and chicanery;
Only Mount Idinen can bear your weight.
It alone remains oblivious to the wind's siege
And ignores the dust's turban.

Ancient, anonymous Tuareg poem

1

The pair of mountains left the mother chain, fleeing from the wind, and agreed that Idinen would explore the desert. It headed north, crowned by the mightiest citadel the desert has ever seen atop a mountain. It had scarcely crossed the plain when the jinn's king stopped it, saying, "We have also decided to settle on the earth and to establish a homeland for our clans. Loitering in the wastelands has exhausted us, and we have suffered from persecution by human beings, who deserve to be stoned. They have come to the virgin desert as aliens, adventurers, and thieves. They have defiled it and plundered its treasures. Throughout the entire desert continent we can find no dwelling more suitable and no refuge more secure than this mighty fortress on your head. Will you sell yourself to us in exchange for our guarantee of protection against the Qibli and the sand?"

Idinen thought for a long time about this proposal. Then it asked, "But can any power block the Qibli?"

The king answered, "Yes, and that one power is the jinn."

Idinen thought some more. Then it observed skeptically, "I would have thought that would take a messenger from the gods."

The king said, "Neither a divine messenger nor fate. Nothing can withstand the jinn."

Awe-inspiring Idinen scratched its mighty head and asked sarcastically, "What forces you to search for a refuge if you do not fear even fate?"

The wise jinni laughed till he threw back his head. Then he replied, "Know that there is not to be found on earth or in the heavens anyone who can claim he has no weak point. We can add to this roster even the gods themselves. Our weak point lies in the human community. They are worse than the Qibli and the gods—indeed even worse than almighty fate itself."

The mountain was baffled and thought for a long time. Then it asked once more,
"What have people done?"
"What haven't they done?"
"...."
"When a man wants to brand someone else as evil, he calls him a jinni. It would be more fitting to describe him as a man. We don't act unjustly. We honor our treaties and believe in the gods. Those in the human community treat each other unjustly, betray every pact, and do not believe in any god. May the gods be compassionate to us and shield us from their stupendous evil! They have wreaked havoc with the desert and stolen all our treasures."

"Would my head suffice to safeguard your treasures?"

"It will suffice, because it is secure. Not a single man will be able to reach it. We debated at length among ourselves before deciding on this location."

"If I grant you my heavenly fortress, I fear I will lose my soul."

"You will lose your soul if you don't give us the fortress. No one is safe from the Qibli and its dust unless he seeks our aid. Look at what it's done to your mother, Acacus. See

how the gods punished the mountain chain in the valley of al-Ajal when it appealed for justice to the gods. The gods chastised it by cutting off all its peaks. Now, bald, it wanders helplessly through the desert and can't summon rain. Not a drop has fallen for forty years."

"It's said that the absence of rain for forty years is a sign of the absence of justice."

The mighty jinni laughed once more. "Do you want a stronger indication of the absence of justice than this? The gods have been stingy with water for you for forty years while providing your enemy seas of sand and dust. If you refuse our proposal, I will soon be saddened by the disappearance of this mighty fortress. See what it's doing now to your twin. It's beginning to scale it from the rear. Ha, ha, ha."

The echo resounded throughout all the desert's mountains. Then they wept in the naked continent and begged Idinen to accept the proposal. They said it would be better if even one mountain to which the gods had granted a heavenly fortress survived, than to have their descendants die out and the offspring of the mountains disappear from the great desert.

Idinen accepted the proposal and sold its soul. The jinn tribes came and settled on it. They placed around its awe-inspiring square citadel an eternal turban of clouds and forbade the Qibli's dust to approach their new homeland.

Then northern Idinen shunned its twin to the south and left it to fight the enemy single-handedly.

2

They jabber a lot in a clearly articulated but incomprehensible language. The people of the plain say that they choose the middle of dark nights for their long, arcane discussions. During the rare seasons of heavy rain, torrents from the heavenly, rectangular peak sweep away the bare branches and trunks of palms, dry boughs from fig and pomegranate trees, and dead vines from vineyards, forcing them down the slope toward the plain. Adventurers and curiosity-seekers whose egos seduce them into climbing the mountain are subjected to attacks by swarms of bees. None of the residents would have believed that this insect, which the Qur'an praises, was found in the desert, had there not been repeated instances of wayfarers and migrants rushing into dwellings after being afflicted by its lethal stings on the mountain slope.

Then gazelles took possession of it, and Barbary sheep took up residence there.

It allowed their flocks to graze freely in the neighboring plains, where hunters competed for them, not realizing that these were enchanted flocks, until the most headstrong fell ill and contracted maladies. People of the plain still pass down stories about the behavior of these wild animals. After being the most skittish of creatures around man, they became even tamer than sheep or camels. The change began when the renowned black hunter Amanay came upon a peaceful herd of gazelles grazing calmly on the open plain near the slope of Idinen. He rolled up his sleeves, revealing muscular arms, determined to bring a banquet home to the encampment, and shot all the arrows in his quiver without managing to hit a single gazelle.

Relating this incident to the tribe's leader, he said that the gazelles were calmly grazing on withered, wild grasses and paid no attention to his arrows. Moreover, the fawns would leap in the air with each shot and utter a shrill bleat. Then they would stick their muzzles back in the plants. The old hunter did not give in, however. He made other attempts, which were equally unsuccessful. Toward the end of his life, he lost his mind, and a sudden illness quickly carried him off.

Mukhammad's fate was even worse. A Barbary ram butted him with its legendary horns and tore out his belly.

The inhabitants of the plain learned the truth, and the jurists' amulets and the imam's talismans proved futile. They forbade hunting the mountain's animals, and hunters were forced to organize hunting trips to the mountains of Tadrart or Massak Satafat or to the valleys of Messek Mellet. The enchanted Barbary sheep would graze together with their herds of sheep and butt heads with the billy goats. The gazelles became quite tame and would stroll with the goat kids into animal pens or houses.

3

Then it was the treasures' turn.

The mountain's residents had no difficulty duping the plains' inhabitants and plundering their prized possessions made of gold. They pursued an ancient path traced by con-artists, bogus jurists, and members of Sufi brotherhoods to gain possession of the women's jewelry and the children's sustenance by exploiting both the desert people's ignorance about their religion and their distance from Mecca. Every schemer who had memorized

some verses of the Qur'an and a few prayers and who could ride a she-ass or a she-camel was able to fleece them under the guise of teaching them the principles of the faith and of returning them to the straight path.

The jinn mastered this chicanery.

They clad their sage in a rough, loose-fitting cloak of the type that members of the Sufi orders normally wore in the desert and sent him to the plain to bring to the people of the desert glad tidings of a new religion. Elders and wise men continued to pass down the wise maxim that the jinni sage used to introduce his mission.

He said, "Every possessor is possessed. Know that. Anyone who possesses gold, we possess. We transform him, haunt him. Know that. Gold and God cannot coexist in the believer's heart. Know that too."

He said he was a member of the Tijaniya Brotherhood. Then — in the presence of a group of tribal leaders sympathetic to the Qadiriya Brotherhood — he attacked his Qadiriya predecessors and accused them of corrupt teachings and of opposing the Sunnah and the Messenger. He also said that the Qadiriya derived their doctrines from the Jews' Scriptures and the Christians' Gospels — not from the Qur'an. He concluded that prophetic deliverance depended on liberation from the yellow metal and on stripping women of their gold jewelry. From his lips people heard the foulest descriptions of this metal. They also heard the most beautiful descriptions of deliverance and the delights of asceticism. Everything the desert people later repeated about inner peace and tranquility or about opposing worldly wealth could be traced back to this gifted Tijani missionary. Moreover, had it not been for this divine talent, no creature would ever have been able to convince even one woman to divest herself voluntarily of her gold jewelry and to bury it in a cavity at the foot of the mountain — the way desert women did that day. It was only a few days after this "Day of Purification" that people discovered that the missionary had disappeared. They searched everywhere and never found any trace of him on this earth. Some at first doubted the affair, and inquisitive folks exchanged many stories, claiming that the strange visitor had simply been a jinni inhabitant of the celestial mountain. They said they had followed his tracks and found he walked with donkey's hooves and that the function of the loose-fitting cloak he dragged on the ground was to camouflage the truth about his feet. A statement was attributed to one of those fortunate enough to have visited Mecca and to have made a pilgrimage to the House of God to the effect that his cloak was in no way a Sufi garment, since in Egypt this man had seen Coptic Christian priests who wore a jubba like it, hanging out in the Bab al-Zuwayla market.

Long discussions flared up concerning his heretical maxim: "Anyone who possesses gold, we possess. We possess him and haunt him." Jurisprudents hesitated over this slip of the tongue, asking: "Why did he say, 'We possess him, we transform him, and we haunt him'? What creature can cause metamorphoses, possess people and haunt them — except for a demon or a jinni?"

Intellectuals, however, embraced the maxim and referred to him as a divine messenger or missionary and a legend. They built a shrine for him in their hearts and remained true to his memory.

Women in the desert were forbidden to wear anything made of gold from that day forward, because factions finally reached a consensus that anyone who possesses gold is himself possessed and that his spirit is a puppet in the hands of Unseen forces.

Desert Discourse
Ibrahim al-Koni

What is the desert? In the Book of Exodus, God says to Pharaoh, through the intermediary of Moses: "Free my people so that they can worship me in the desert!" Thus the desert is a sacred place, a sanctuary. The chosen people must traverse the Sinai desert, in order to be purified of polytheism, before they can arrive at the promised land. In other words, the desert is also a place of purification, or a'rāf in the language of the Koran. Sanctuary, purgatory, but also liberation, which is synonymous with death: that is the desert for me. These notions about the desert are postulates or, if you like, amulets, mysteries, which I attempt to approach each time from a different angle.

I am reproached, sometimes, for being repetitive, for recreating the same scenes and the same characters. But when it comes to the desert as I have described it, repetition is an indispensable aesthetic, which should not be confused with an objective viewpoint. The desert isn't something given, a priori, it is a personal construction. I created my own desert from my own symbols. I established archetypes. And it is natural that these archetypes should be repeated, so that they can be grasped and understood better by the reader. So it is with the figures of the Chief, the Magician who advises him, and the Beauty, who is the representation of femininity, of Eve. They repeat themselves, but always so as to add something new.

It is the same with myth, which is the soul of the desert. A desert without myth is an absolute nothing. Yet myth is not just an aggregation of symbols. It concentrates millennia of the desert's cultural history. There in the desert, about eleven thousand years ago, was born an extremely rich culture. Witness not only the rock art that has been discovered, but also the fables that were born there and that have come down to us. It is accepted, in fact, that it was the Tuaregs who founded Egyptian civilisation, when they migrated towards the valley of the Nile. Some settled there permanently, while others turned back to the desert. Through the use of myth, which is much the same as articulating the voice of the desert, my series of novels aims to embody and bring to life all this little-known culture, that has reached us in piecemeal fashion.

Take as an example the fable of Wāw. It is repeated in the theme of l'Atlantide or Paradise Lost. It takes the form of a lost oasis which, from time to time, appears to certain virtuous travellers, and then disappears. It is simultaneously real and unreal. It is closer to a man than his own heart, since it exists nowhere other than inside us. Wāw says that one cannot find paradise, peace, happiness other than inside oneself. "Look for nothing outside yourself," says the Latin proverb. The principal sorrow of man results from the belief that he can find happiness outside himself. Simple mistake. You will find your treasure only in yourself, as the mystics tell us. God is inside us.

Let us now speak of the gods of the desert. The great Sahara did not know monotheism. I think, however, that God is present there more than in many other deserts. For God is present wherever nature is found. I have always been interested in the problem of the unity of the creation, and indeed of the unity of the creation and the creator. God, humans and animals are to be found united in a single body that is called the Sahara. That is why, when one kills a waddān (wild sheep), one is striking oneself. When we cut down a rare variety of tree, such as the Ratl, we are amputating ourselves. Whoever destroys nature, destroys humanity; whoever kills a tree, assassinates a tribe. It is not a question therefore of respecting just the life of animals, one must respect equally the life of plants and even of the topography. Let us not deform the mountains, let us not suppress the vestiges of ancestors, nor transform them into construction materials for the building of cities. Nothing in nature should be touched. A Taoist maxim says: "Wisdom consists in abstaining from all action, absolutely." That is true, for in the end all destruction is self-destruction. We know from experience that we ourselves are the cause of all the problems with which we are confronted today, and that it is perhaps too late to deflect the menace that confronts us: the destruction of nature. In a sense, we are criminals. This question is fundamental to all my works, which form a kind of lament, indeed a forewarning of the extinction of life.

Visiting Death
Ibrahim al-Koni

The question of the desert is a question of being. In reality, the desert is not a desert, but a symbol of human existence. For if we examine it a little, we discover that this desert, this rich desert, with the presence of the soul, is a paradise. For any civilisation, or city, without a soul is *jahib*. That is the distinction. In my work the desert therefore has an existential dimension, a metaphysical dimension, for in reality the desert is not a place; a place has preconditions, and one of the preconditions is water, and the lack of water in the desert makes it impossible to settle there, so the desert becomes a place of absence, a place that is a shadow of another place; a place that invites *dahsha*. For how can one write about a place that does not meet the condition for being a place? How can one write, as is the purpose of my work, a novel, an epic work that is divided into chapters, about a metaphysical place?

It became clear that I was facing the challenge, not of doubting the desert, but of transforming the desert in my novels into a manifestation of something that cannot be manifested. It is about the problem of both time and place in the desert. If one suspects the desert of being a place without limits, one can also question the concept of *time* in the desert. And those who read my works will discover that time as it is manifested in the desert is a time of fable, a hidden time. Because the place which is also unconnected with the speeds that are characteristic of civilisation in the city, that is boundless and unconnected, must necessarily also influence time. That is why time in the desert is not traditional time either; it is a permanent time, an eternal time, without characteristic features, where past, present and future exist at the same instant. This invites us to contemplate and investigate the desert as a philosophical phenomenon. Oddly enough, this has not happened so far. The desert is still a virgin treasure. For the normal view, the typical view in the world, is that the desert is empty, that the desert contains nothing, and that the desert is an absence. But that is not true. In reality *everything* exists in the desert, despite the fact that it is inaccessible, forbidding, harsh, merciless and punitive by nature. It is also

inviting and arouses passion in whoever wishes to take the world by storm. And why so? Because it is freedom. Freedom in the sense that Immanuel Kant gives it, that is freedom as something that is the opposite of one's nature. The freedom that is associated with the sublime experience. For in the desert we are present in nature, while at the same time we are outside nature. In reality we are present in freedom. And what does freedom mean? Freedom means death. In the desert we are at the dividing line that is between us and death. And that is in fact a kind of cure. For it is only in the desert that we can pay a visit to death and afterwards return to the land of the living.

The saints come from the desert, the prophets come from the desert, the sources come from the desert, and why is that? Because there is hope in the desert, because it is the only true dividing line between true freedom and existence, between death and life. And there is no other place where it materialises, only in the desert. That is why the desert is a complete system, the desert is complete knowledge that does not exist anywhere else, that cannot be reduced to words. And all that I try to do is put words to this vanished dimension, as I call it. For the desert is a vanished dimension and a vanished paradise — that is, it is present, and can return to paradise, for the desert is a spirit that has materialised.

A rock pile ceases to be a rock pile the moment a single man contemplates it, bearing within him the image of a cathedral.

Antoine de Saint-Exupéry, Flight to Arras

New Desert Myths

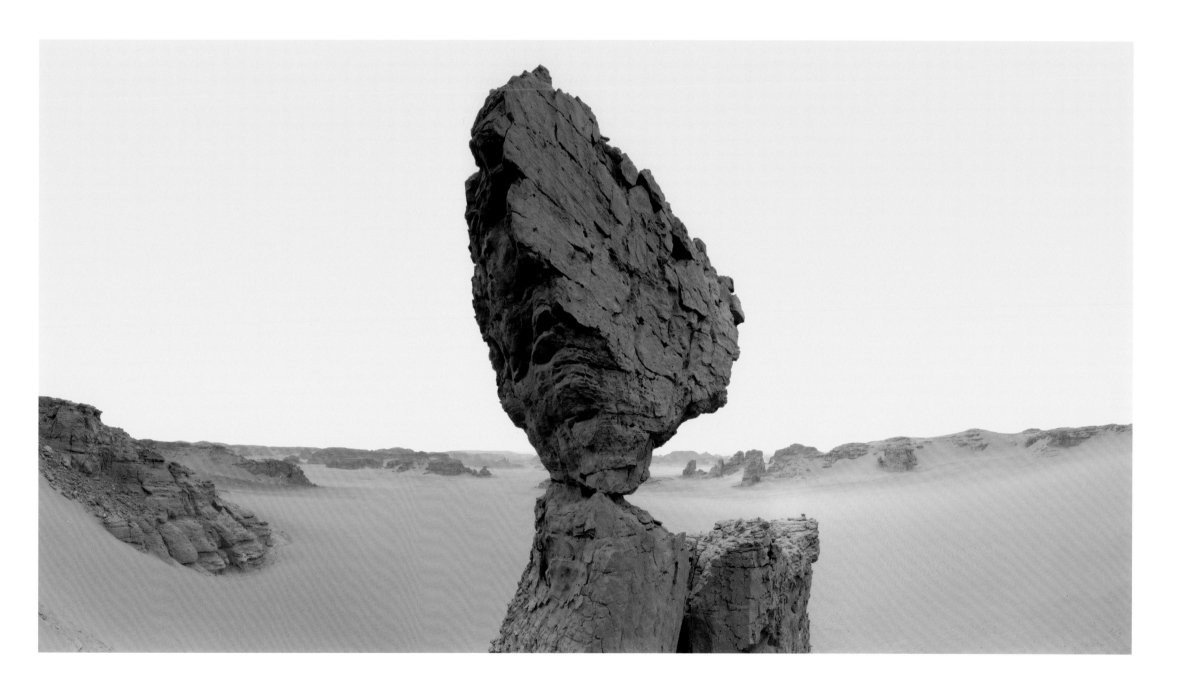

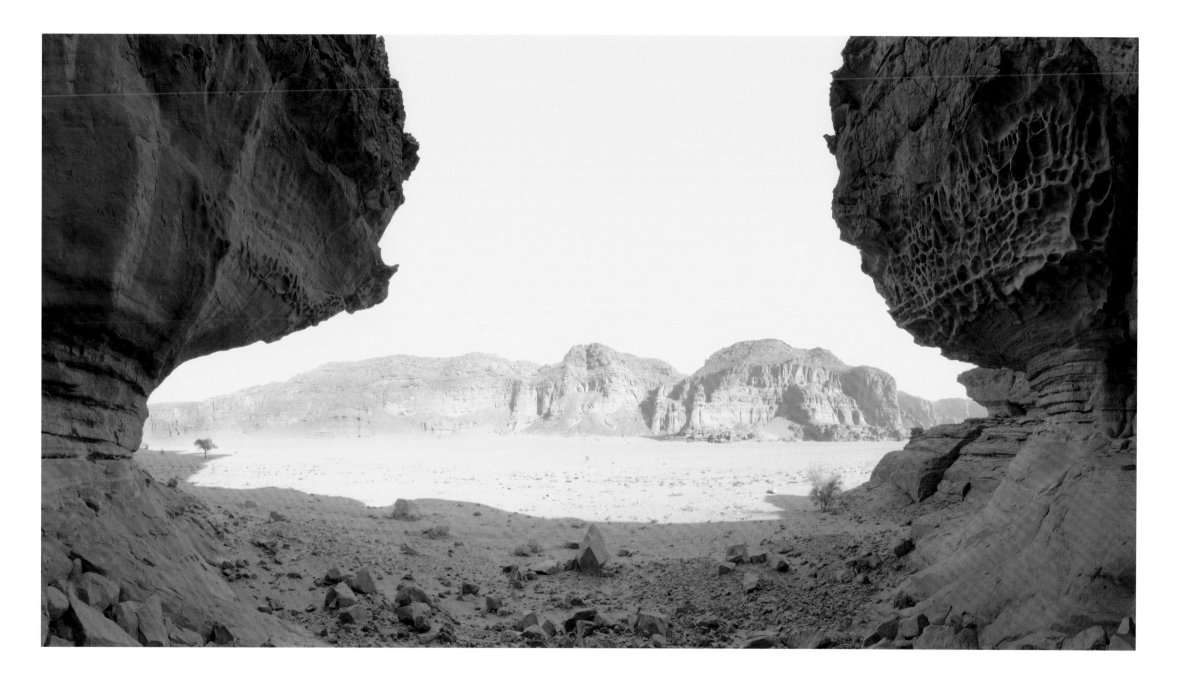

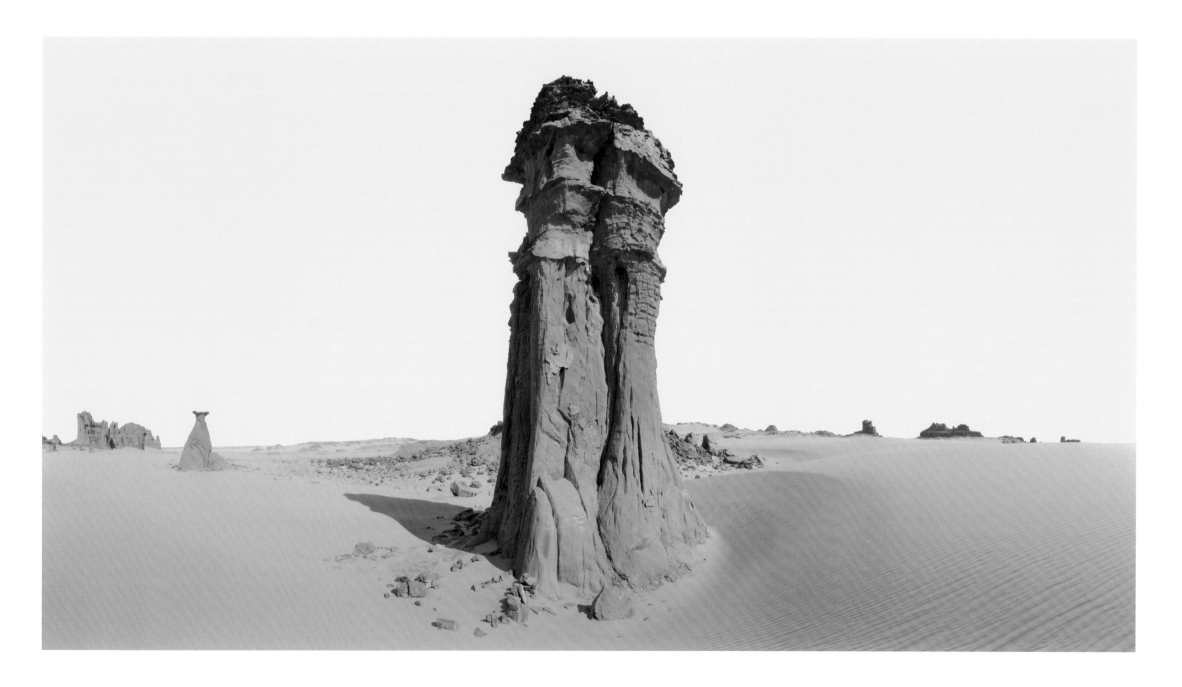

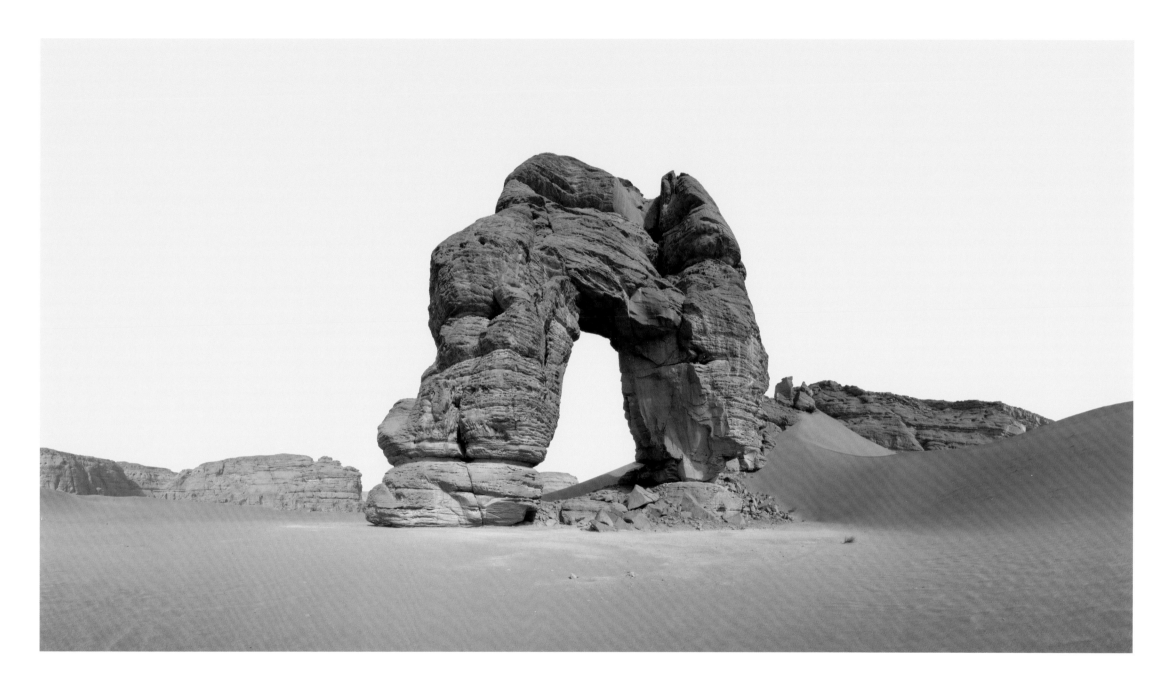

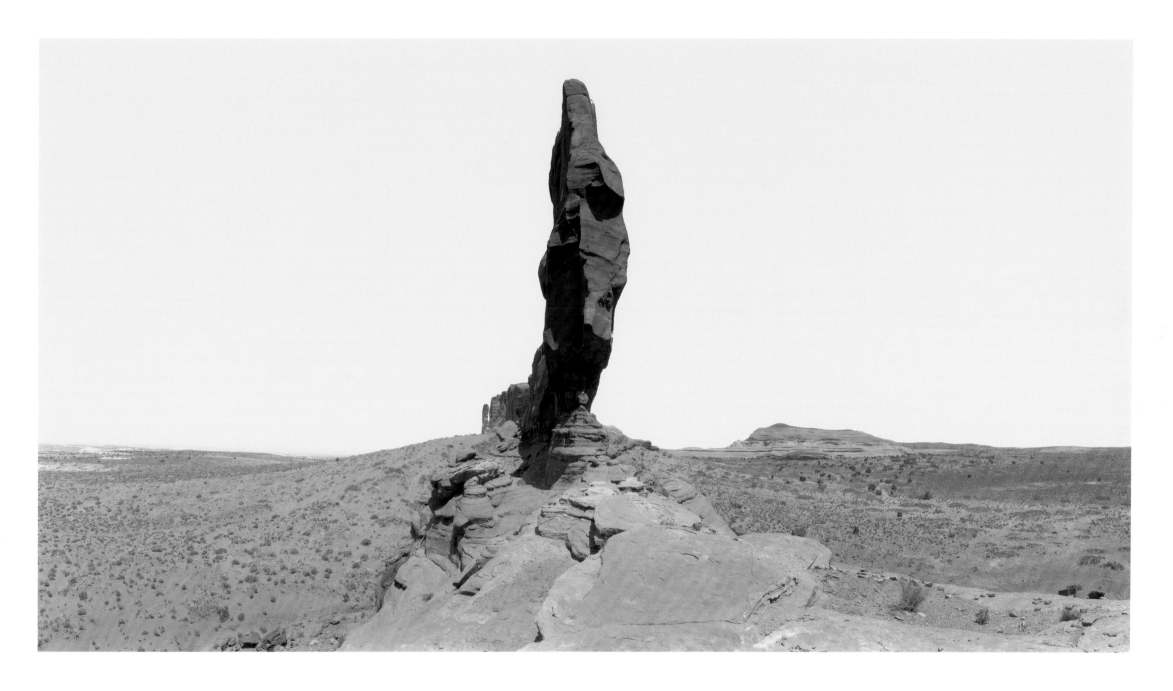

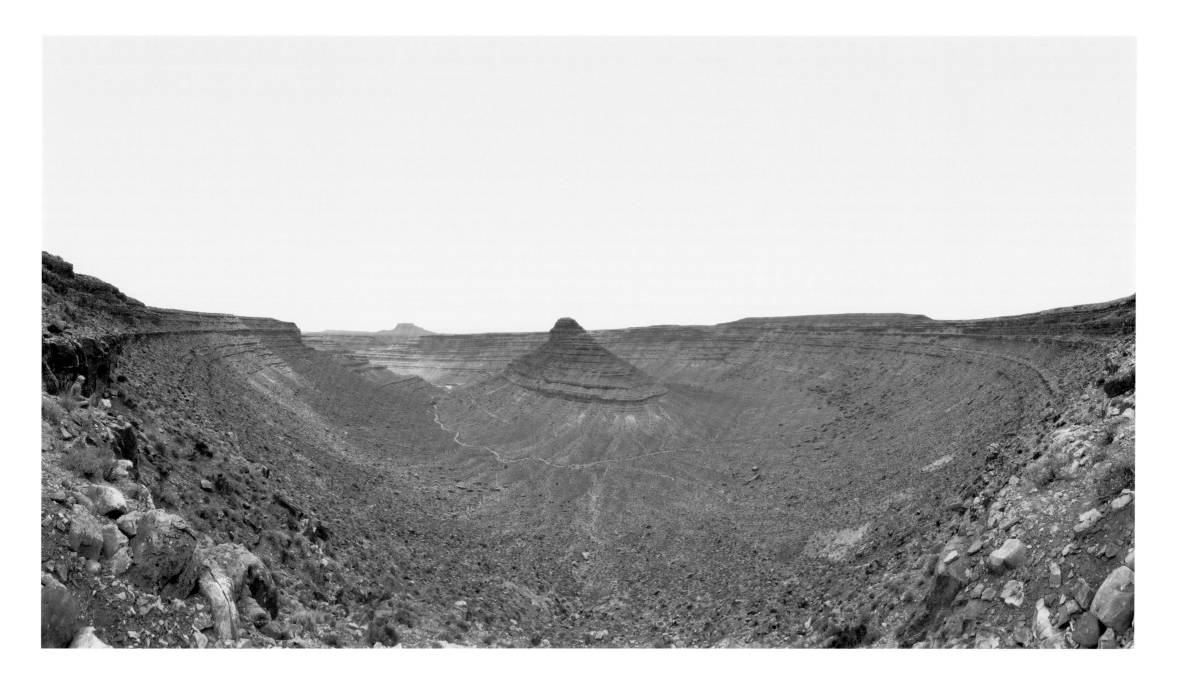

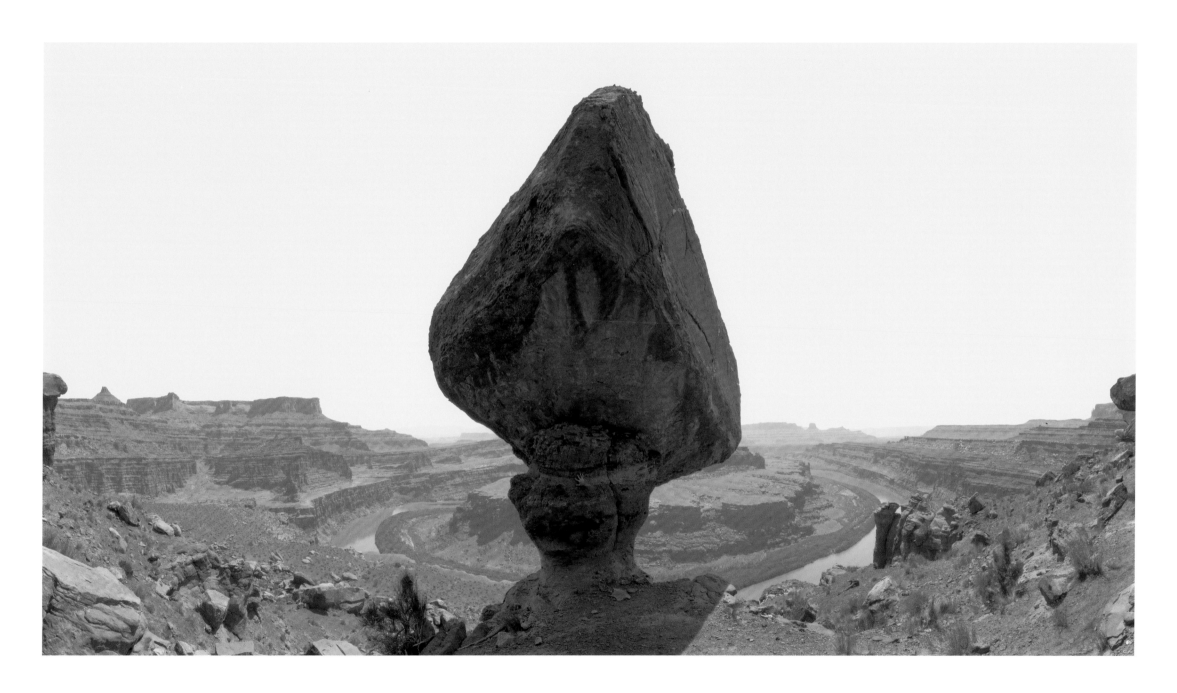

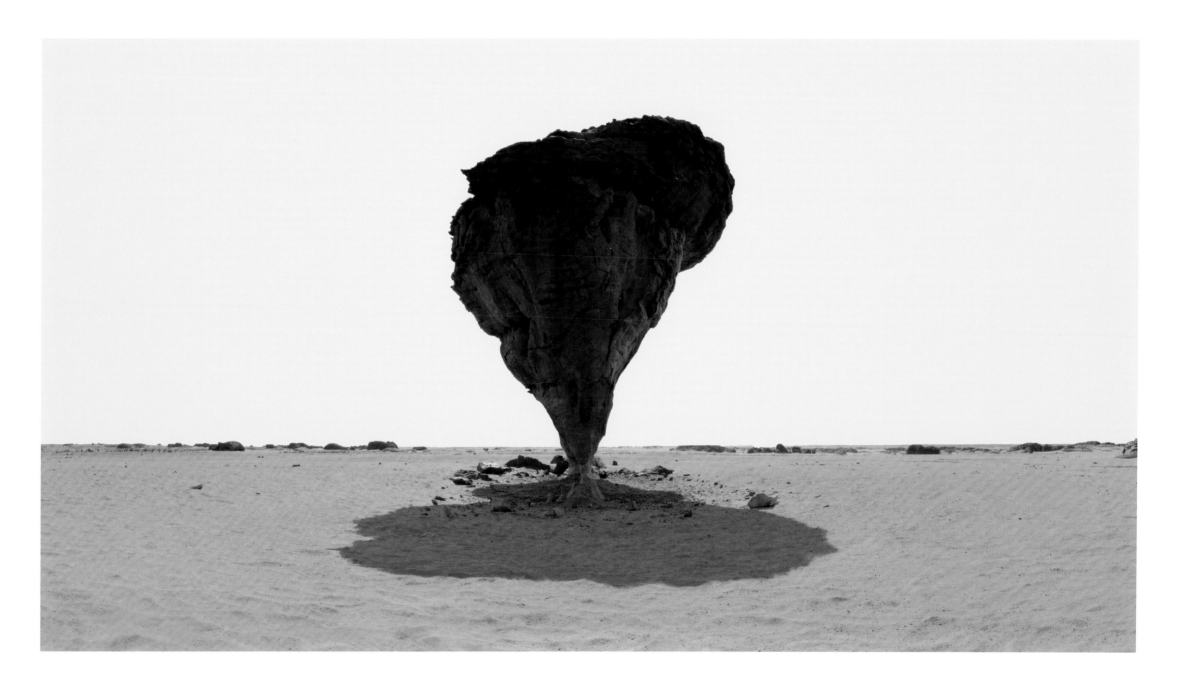

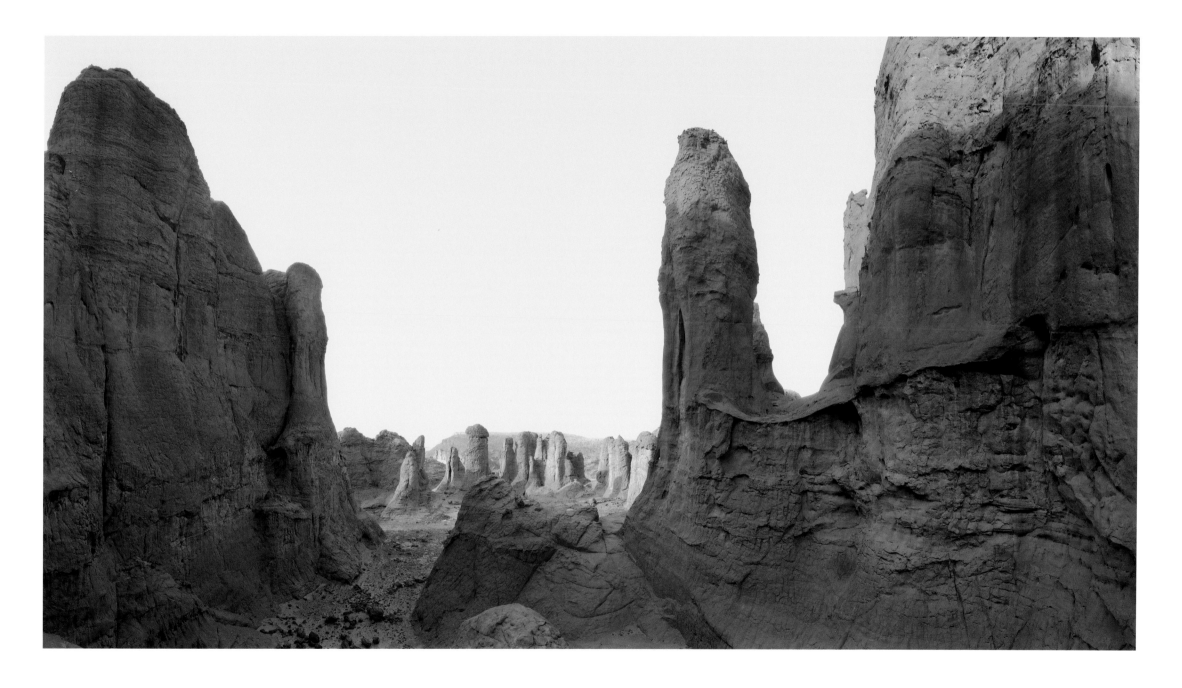

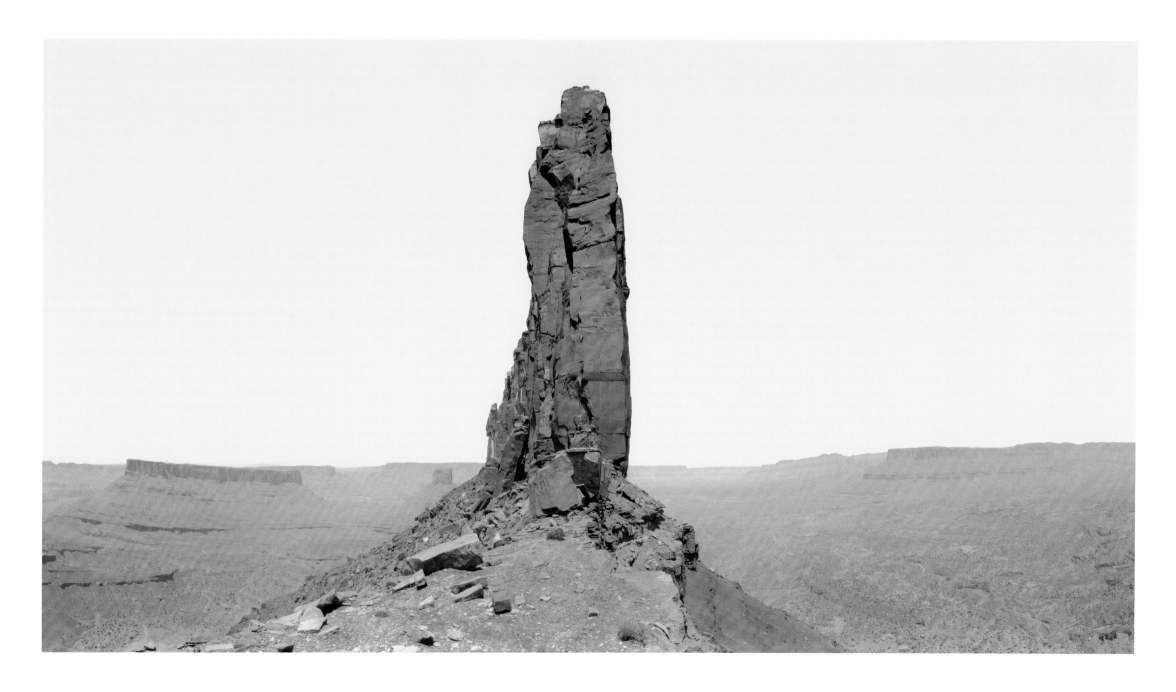

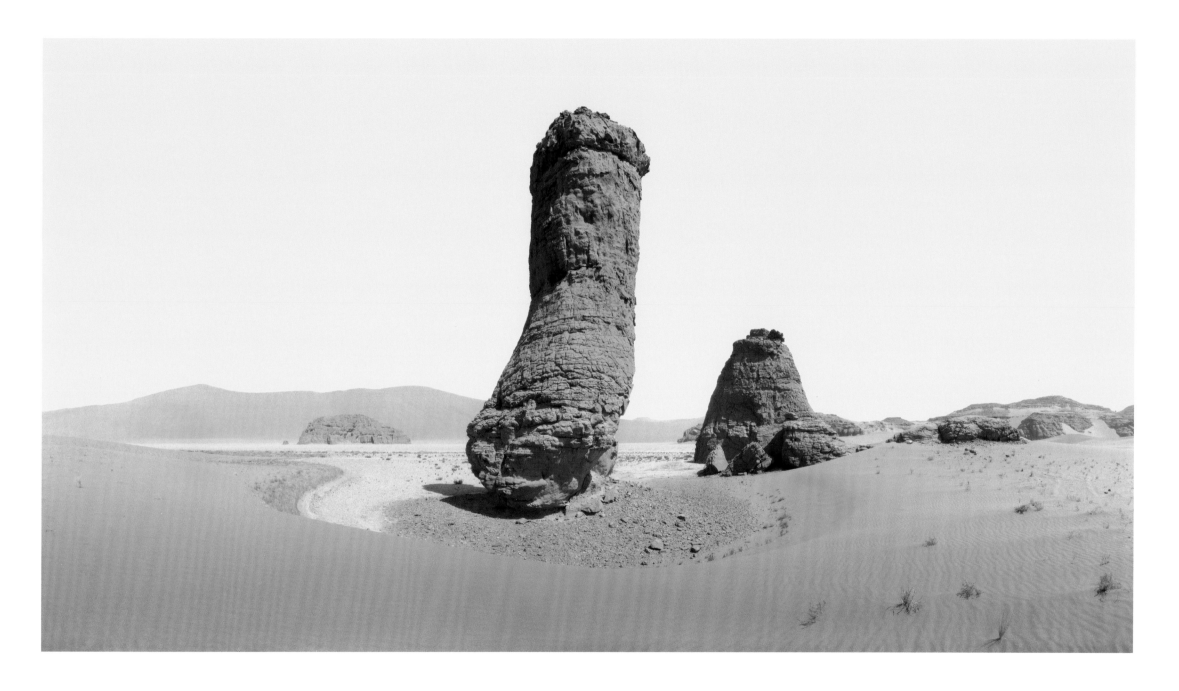

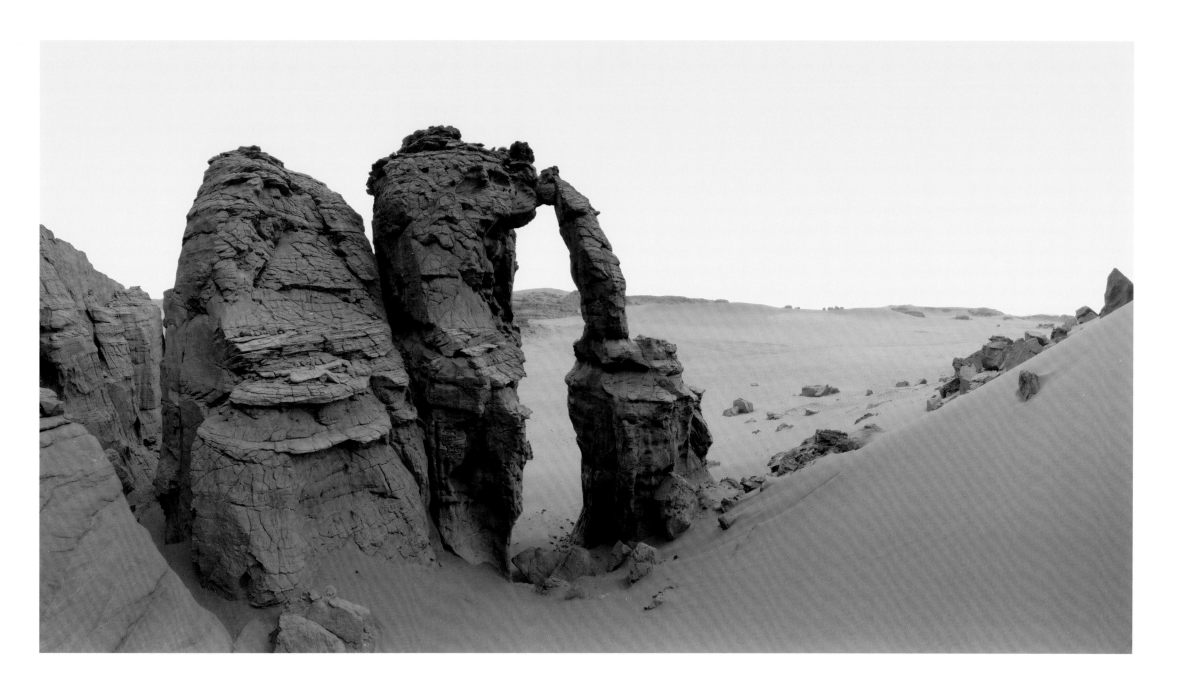

The desert, after all, is never deserted, people live there eternally.

Andrey Platonov

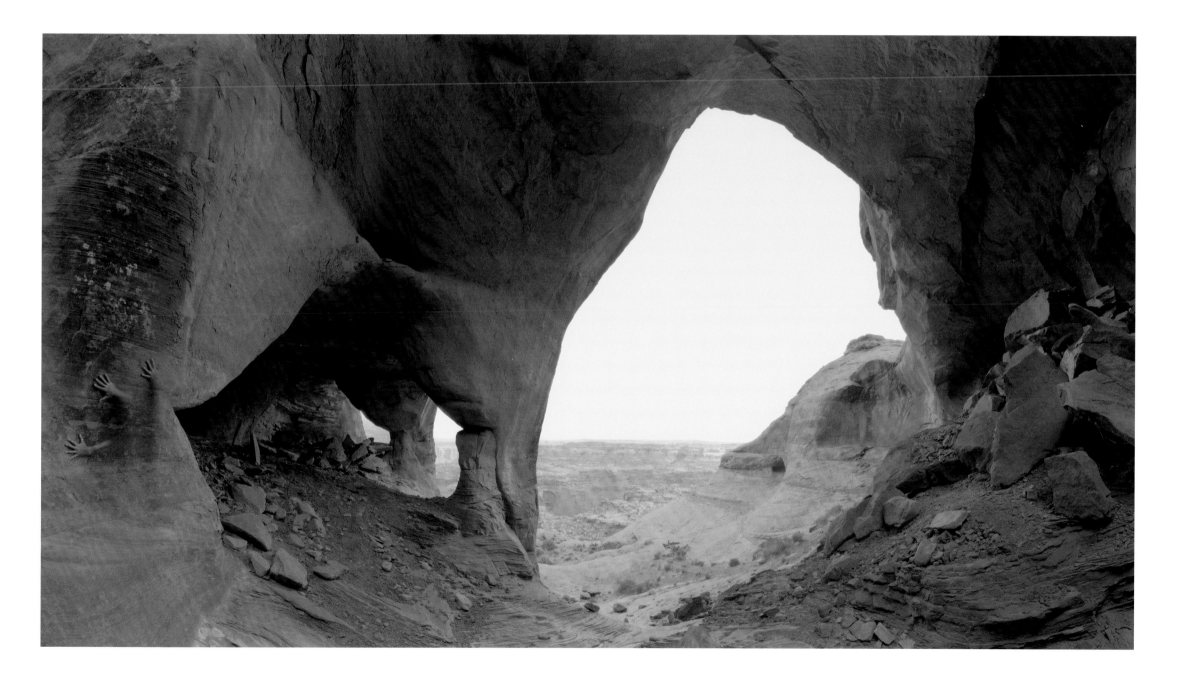

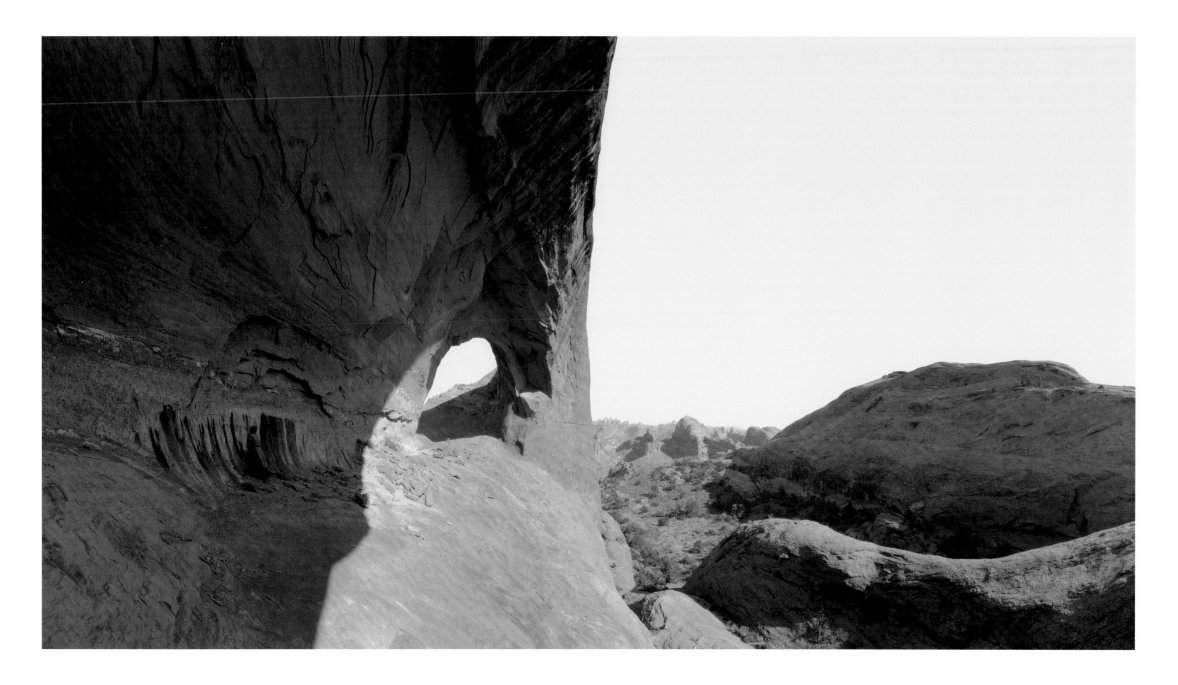

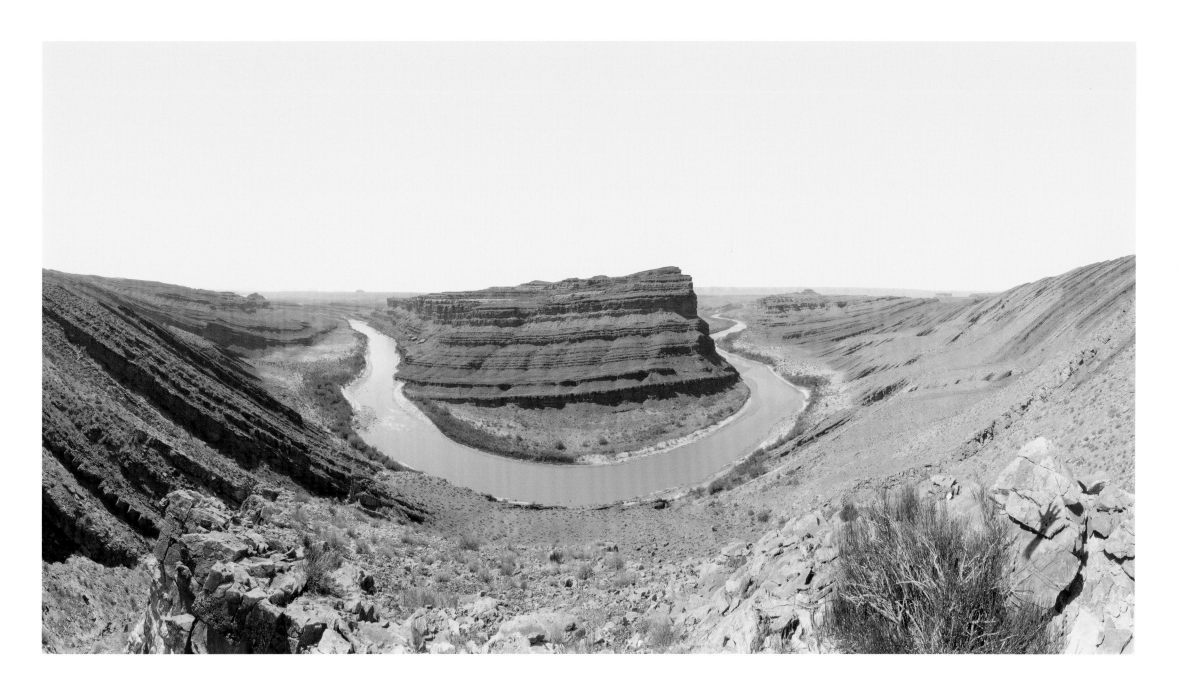

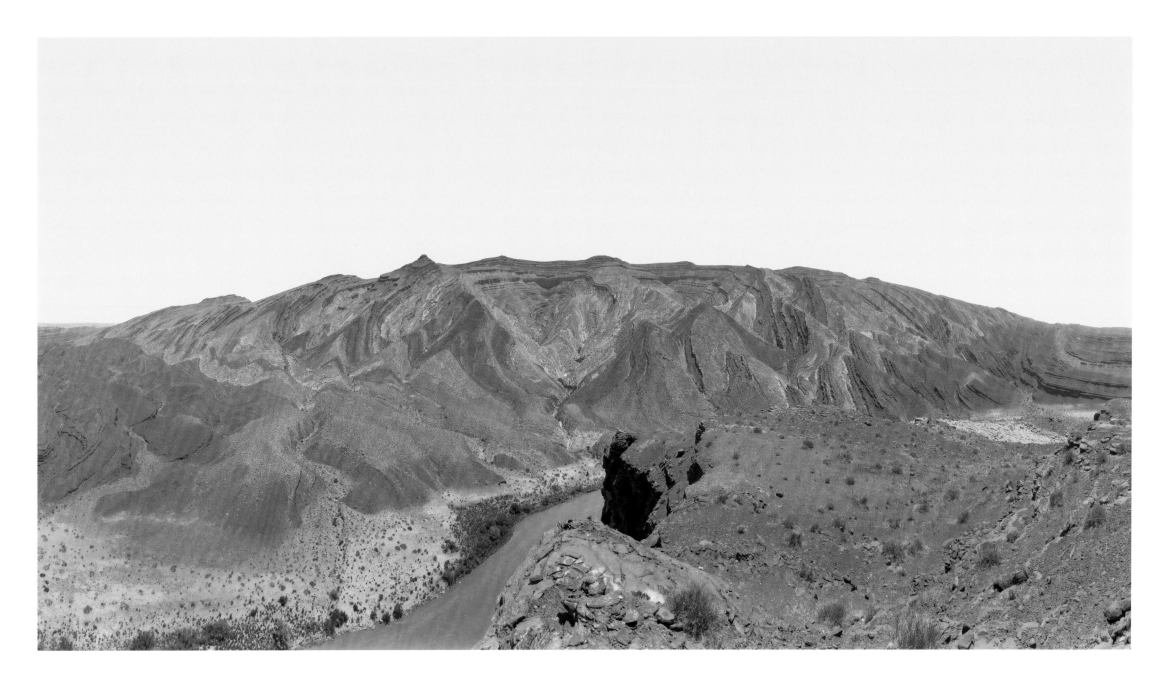

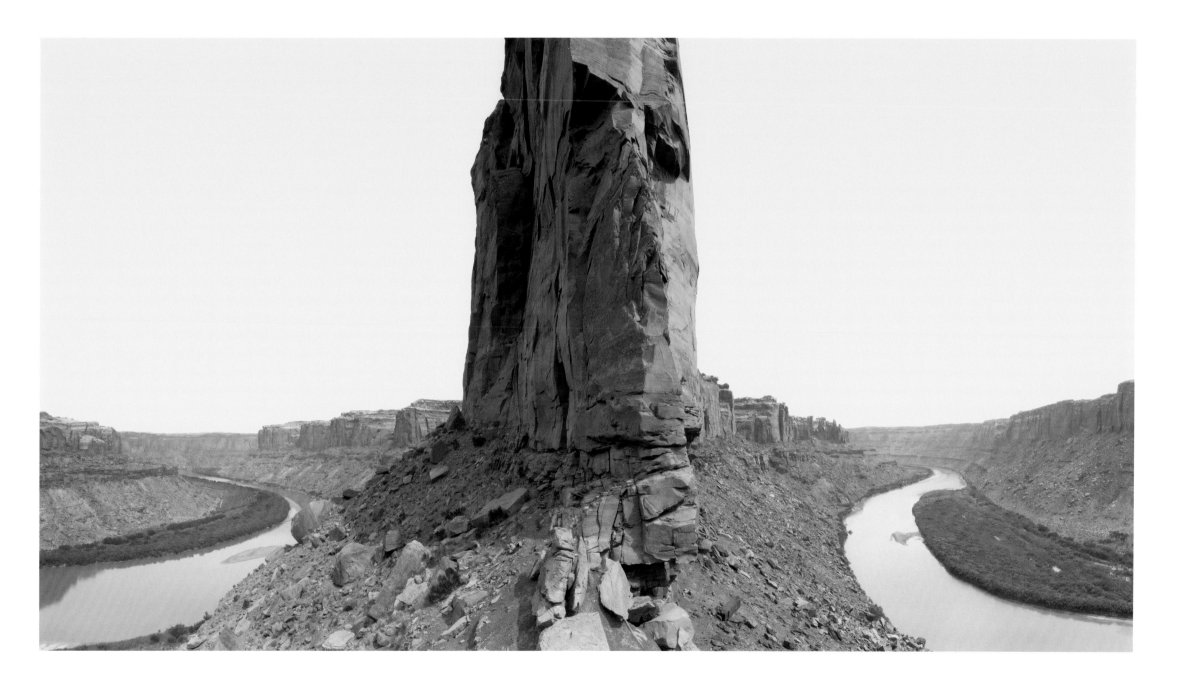

Water cleanses the body and the desert cleanses the soul.

Ibrahim al-Koni

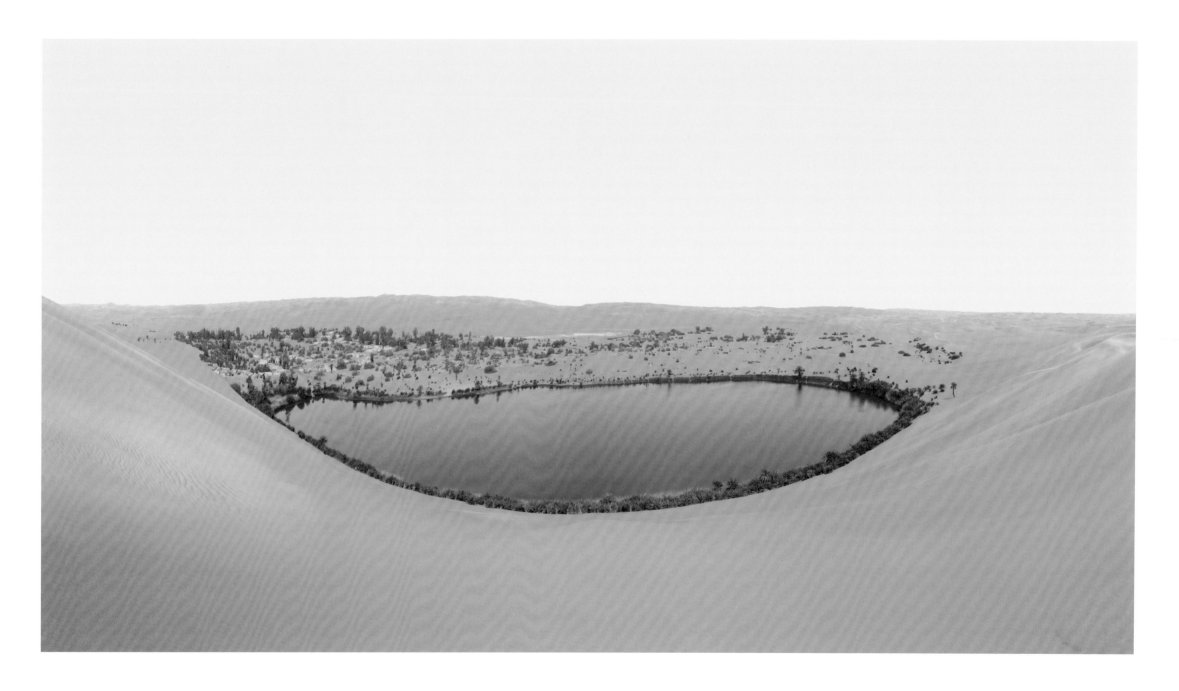

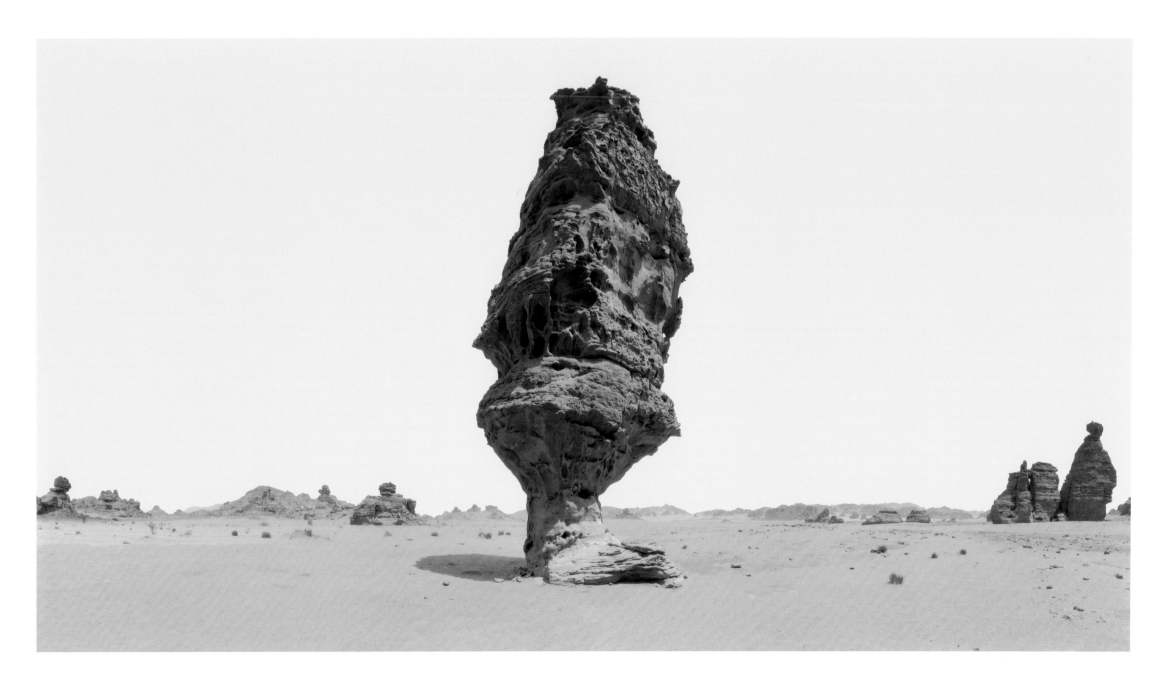

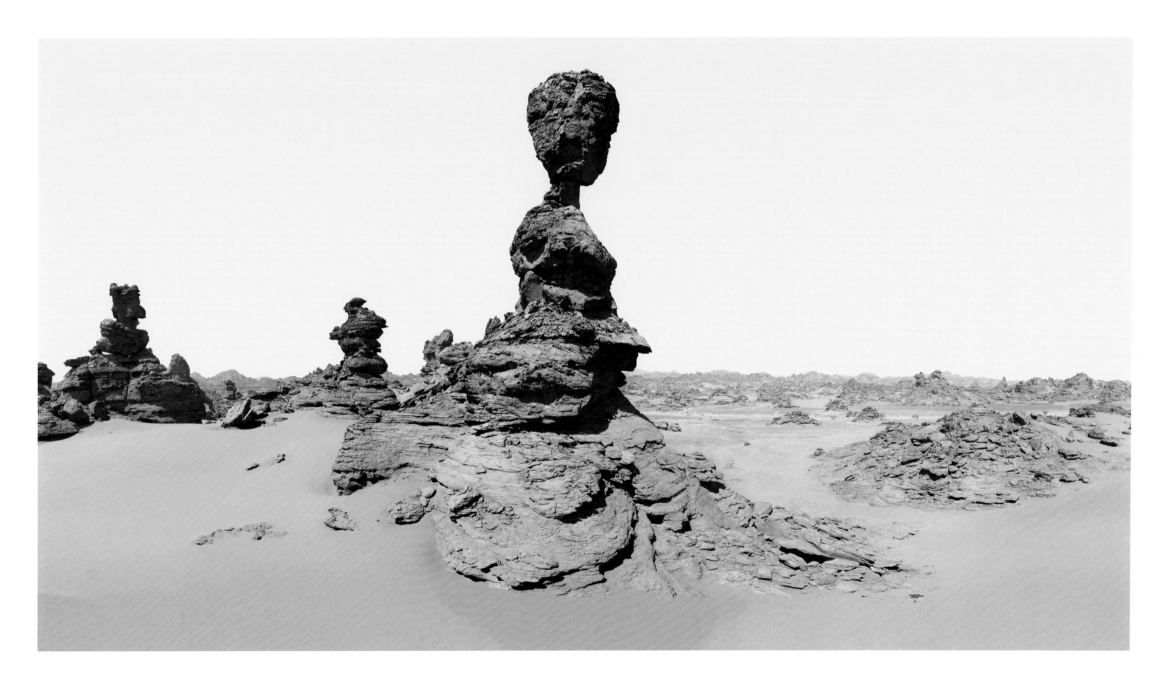

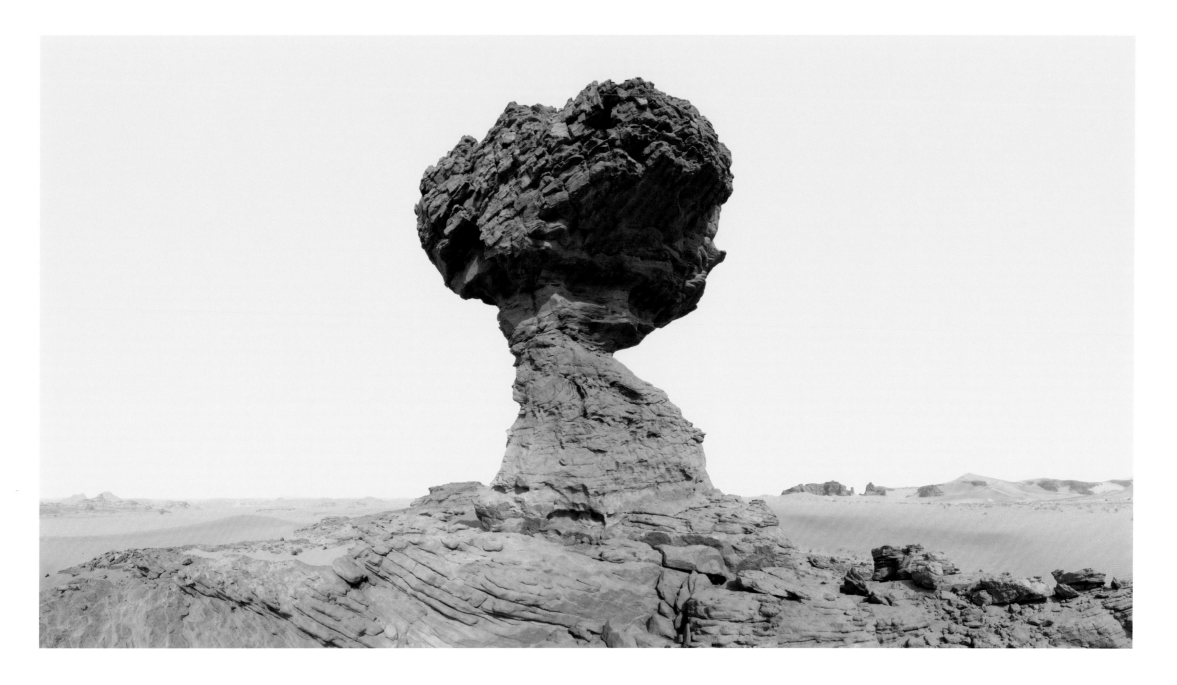

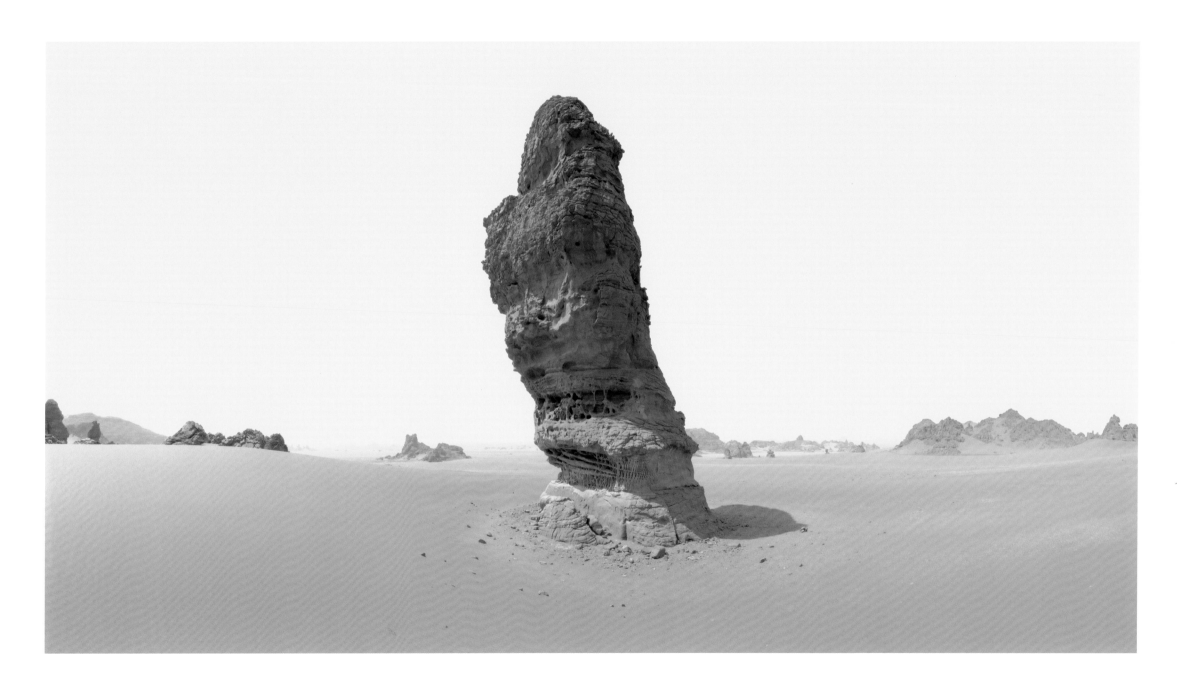

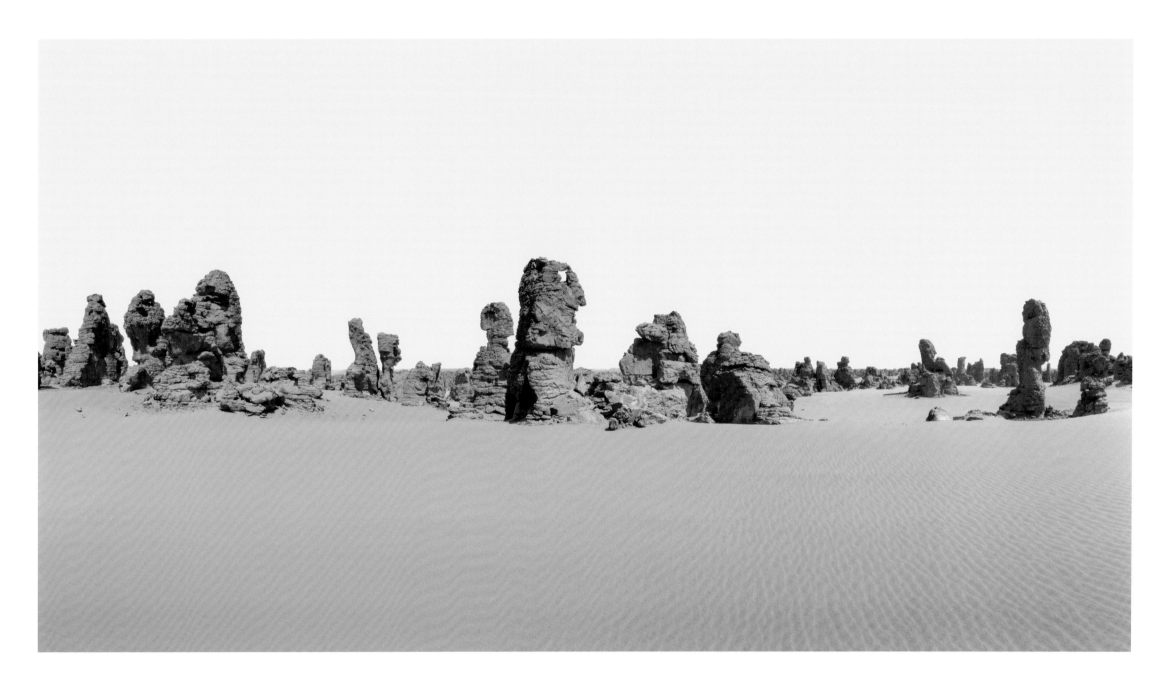

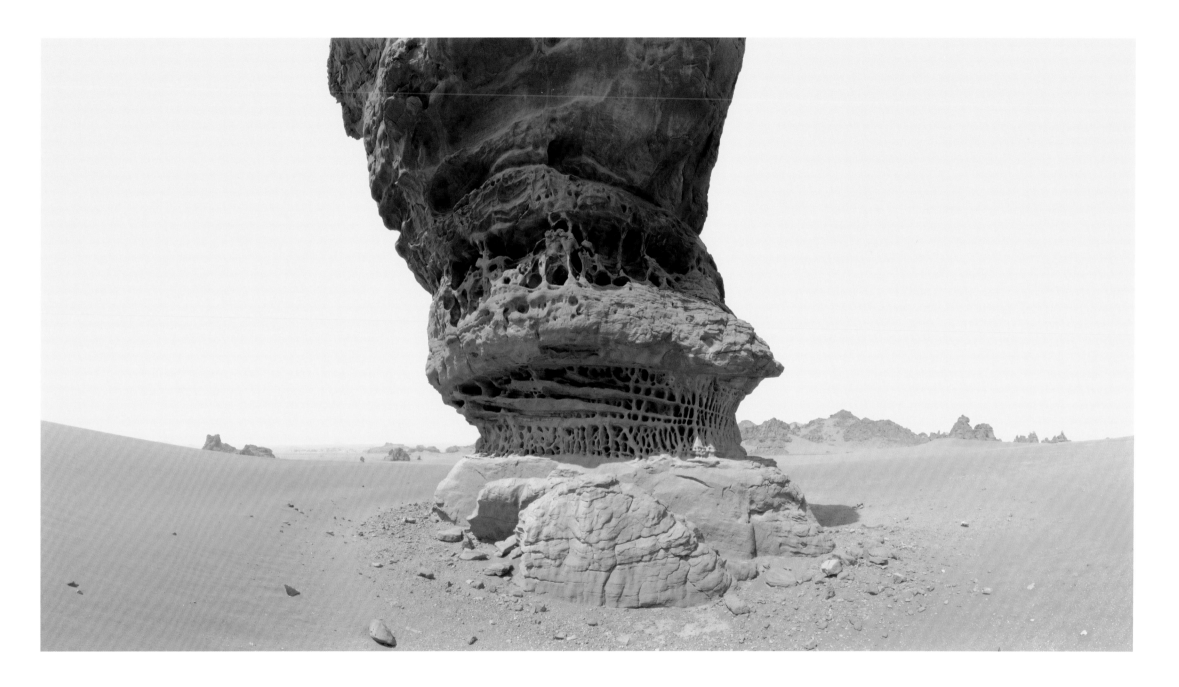

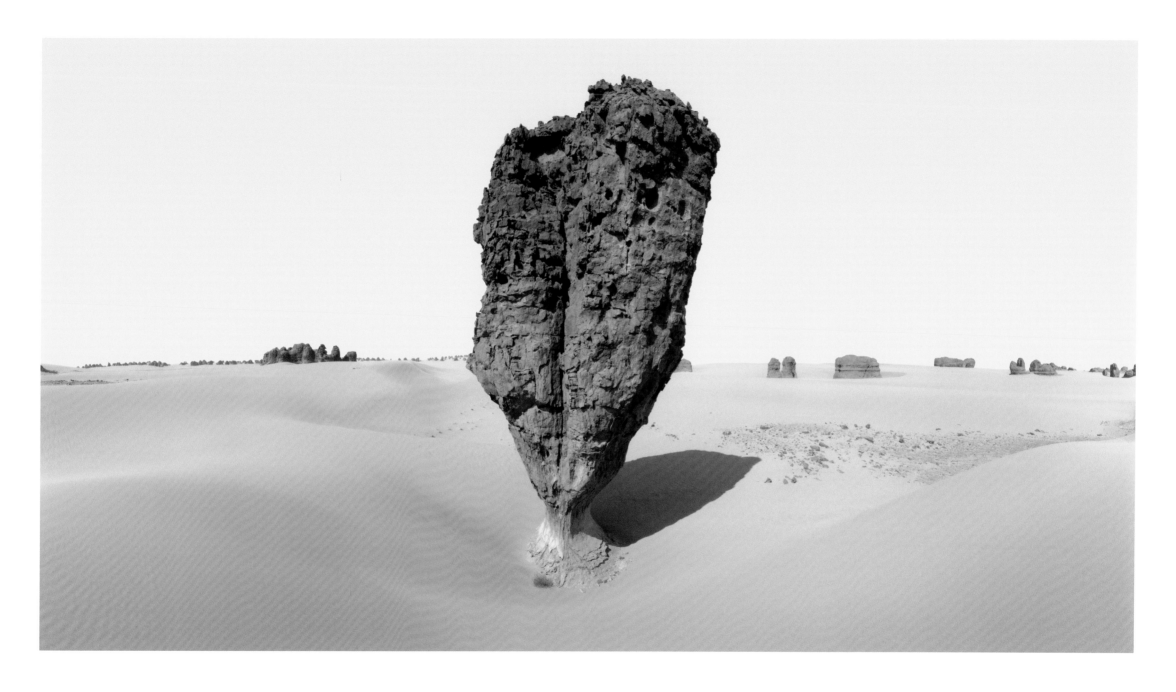

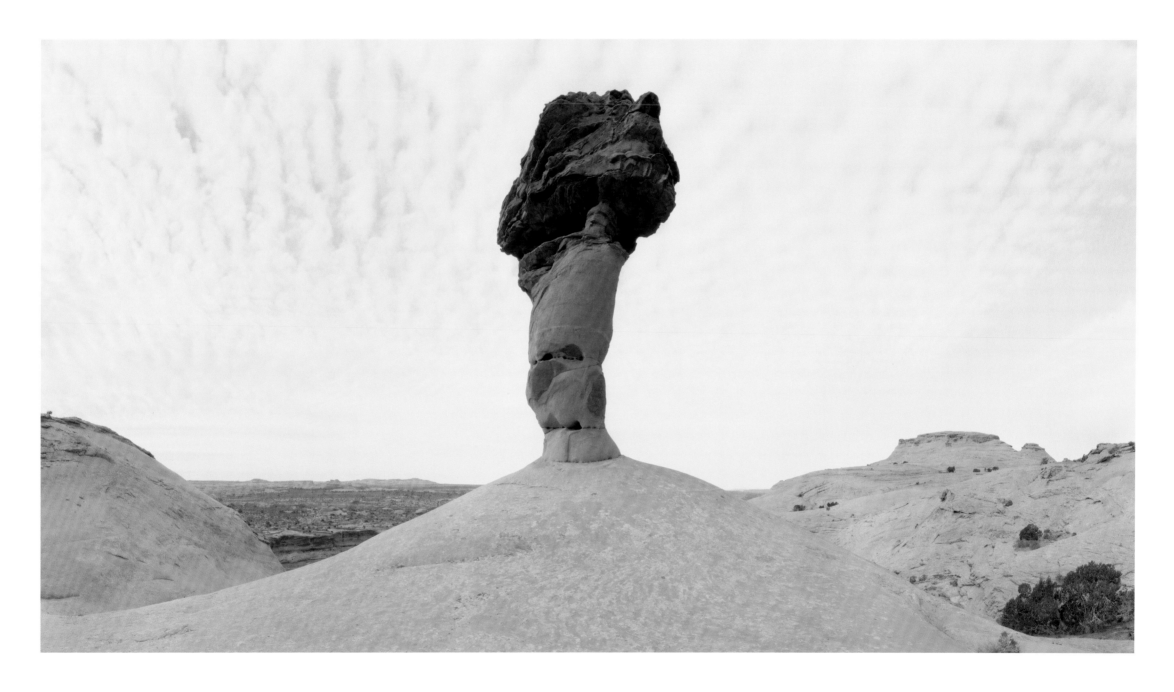

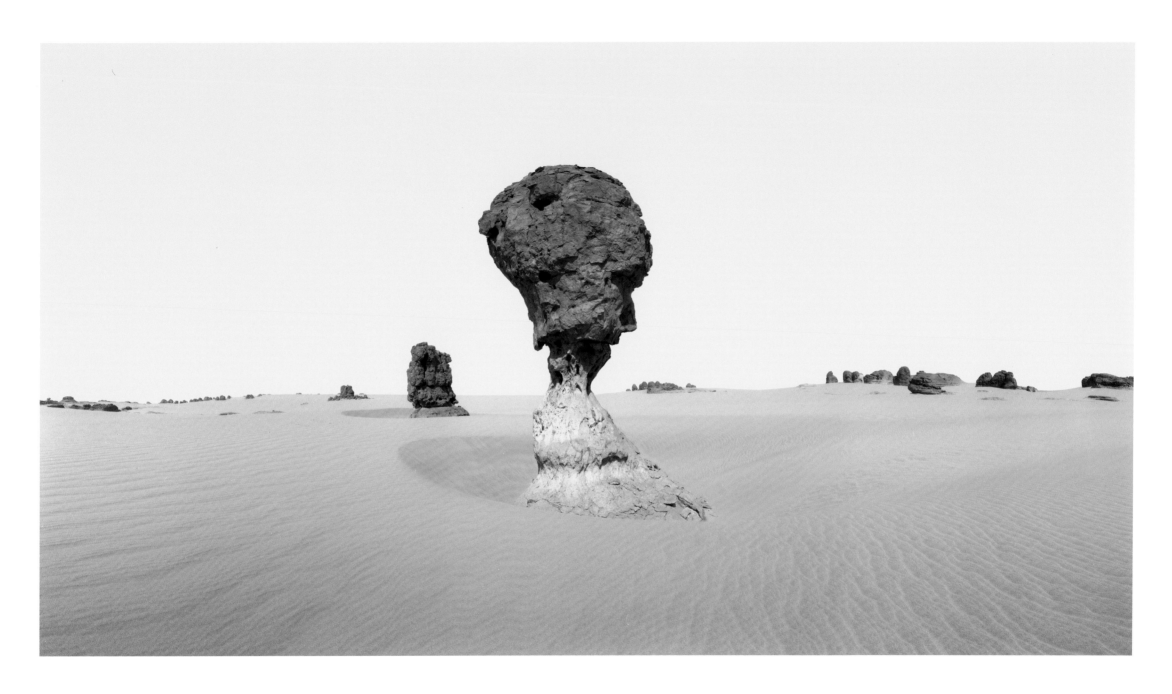

A man in a desert can hold absence in his cupped hands knowing it is something
that feeds him more than water.

Michael Ondaatje

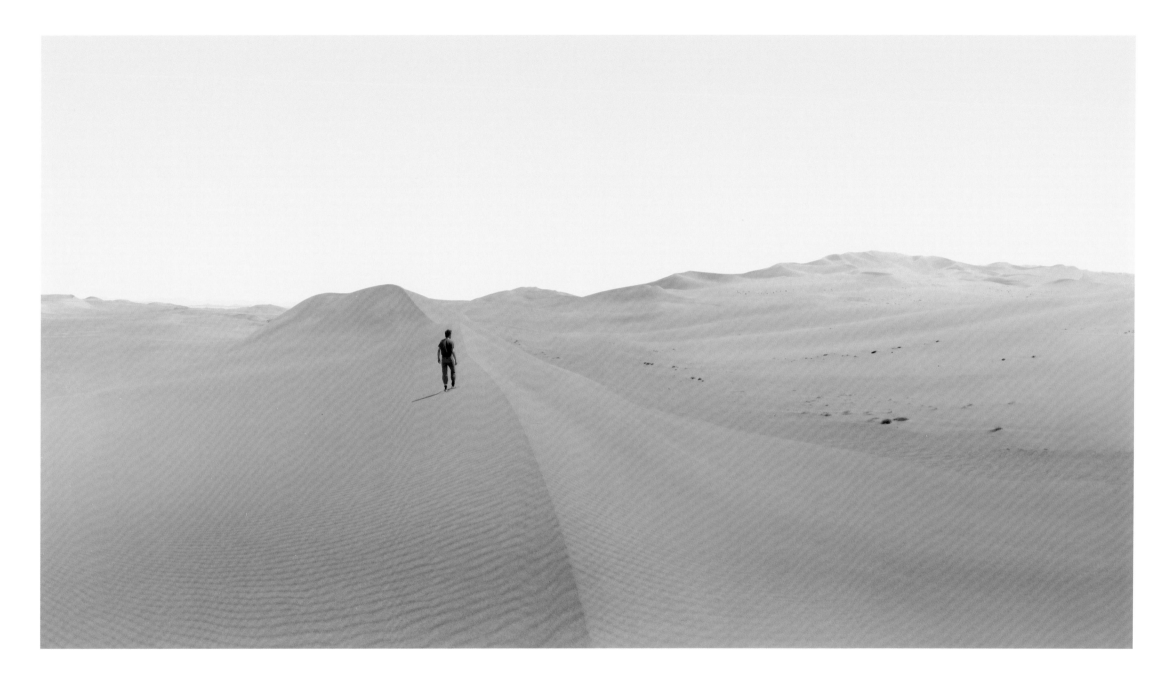

Acknowledgments

The *Sirens* series is the result of many journeys in small boats around remote coastlines, places disturbed only by the elements, bird cries and the occasional fisherman with his lobster creels. These sea-stacks are often invisible from the toe-path and therefore remain unregarded, even by the mapmaker. A sense often comes over me in these places, of entry into a forbidden timeless realm, where geology is altered in the mind into the stuff of myth. I was fortunate to enlist the help of a select group of hardy mariners — my local 'Charons' as I like to think of them, who steered me safely and patiently through the secret pathways of the sea to view these floating sculpture gardens. Without their unstinting help and enthusiasm, much of what these pages contain would have remained unseen. Rod Feldtmann, Gibby Fraser, Keith Gwillim, Robert Howden, Bob Irvine, Raphael Renard, Peter Sinclair, Yiannis Havakis — my thanks to them all. Michael Marten accompanied me on several voyages and we shared many cheery evenings in various cottages noisily devouring his wonderfully garlicky cooking! I must also thank Graeme and Dorothy Storey for their boundless hospitality and great good humour. Simon Fraser's 15-minute abseiling course helped me secure a picture that had eluded all my previous efforts. Isobel Holbourn saved me from a gruelling walk with my heavy camera on an island with few cars and fewer roads. Afterwards we shared tea and biscuits, not to mention a peerless sea view. Emily Anderson and Joy Corley introduced me to local mariners, favours for which I shall always be in their debt.

The making of *New Desert Myths* ran in parallel with *Sirens* — one reason why they share similar motifs. Without the hospitality and generosity of Tom O'Keeffe and Laurie Lamberson this series of images would have been much the poorer. They shepherded me up and down rocky scrambles, and river crossings on tyre inner-tubes that I wouldn't have dreamt of attempting alone. Sinclair Stammers joined me for one trip into the sandy wastes, making me the sole beneficiary of his considerable knowledge of things palaeontological. David Earle also joined me on one trip, flavouring our experiences with his elliptical observations and wit. I also thank Mara Kahn, and the two tiny anonymous climbers on NDM XX for so patiently posing for me.

I am very grateful for the enduring support of Michael Hoppen, Robert Koch and their respective galleries, and Alex Percy at Acte2Galerie. This book would not have been possible without the generosity of Alex and Michael. Thanks also to Ada Takahashi, Genny Janvrin, Catherine Caldwell, and Clemency Cooke for their strong support over many years. More recently the enthusiasm of Flo Peters has been greatly appreciated. Gerry Badger also made valuable contributions to this project.

I am very fortunate to have Marina Warner's collaboration on this work and lack the words to adequately thank her for opening up the siren myths to us so eloquently, and also for her patience and generosity. Her suggestion to invite Ibrahim al-Koni to contribute to the desert section of this book was inspirational. I am deeply gratified by his enthusiastic support of this project. I also wish to thank Margaret Obank of Banipal Magazine, and Professor William Hutchins for the very considerable assistance he has given me regarding Mr al-Koni's texts, and again, Michael Marten for his unstinting help with translation.

Finally, my heartfelt thanks go to Jenny and Oliver; they have borne my many absences with great understanding, and therefore it is to them that this book is dedicated.
David Parker

Ibrahim al-Koni, The Errant Twin, an extract from *al-Majus*, (The Fetishists), Part I, Section 4,1991 trans. Prof. William Hutchins, used with the consent of the author and the translator.

Ibrahim al-Koni, *Desert Discourse* published in *La poétique de l'espace dans la littérature arabe moderne*, edited by Boutros Hallaq, Robin Ostle, Stefan Wild, Presses Sorbonne Nouvelle, 2002; extract trans. by Michael Marten, 2014.

Ibrahim al-Koni, *Visiting Death*, edited from an interview on 28 Oct. 2013 in Barcelona for the 2014 exhibition, *Arab Contemporary: Architecture, Culture and Identity*, at the Louisiana Museum of Modern Arts near Copenhagen, Denmark.

Homer. *The Odyssey*, trans. Robert Fitzgerald, William Heinemann 1961.

Ibrahim al-Koni, *A Sleepless Eye: Aphorisms from the Sahara*, trans. Roger Allen (Syracuse, Syracuse University Press, 2014), 69.

Ibrahim al-Koni, *The Bleeding of the Stone*, trans. May Jayyusi and Christopher Tingley (Interlink Books 2002).

Andrey Platanov, *Soul*, trans. various (Harvill Press, Random House UK 1935).

Michael Ondaatje, *The English Patient*. (Bloomsbury 1992).

Antoine de Saint-Exupéry, *Pilote de Guerre*, (Éditions Gallimard 1942). Flight to Arras, trans, Lewis Galantière.

David Parker was born in England in 1949. He studied engineering and technical illustration before developing a career in commercial and scientific illustration and photography. He has produced two photographic monographs including the award winning *The Phenomenal World,* and his work is in numerous photographic collections, private and public. www.davidparkerphotographer.com

Ibrahim al-Koni was born in Libya in 1948. A Tuareg who writes in Arabic, he spent his childhood in the desert and learned to read and write Arabic when he was twelve. He studied contemporary literature at the Gorky Institute in Moscow. He is the author of over eighty volumes, including novels, stories and aphorisms, and has been translated into thirty-five languages.

Marina Warner's most recent book is *Once Upon a Time: A Short History of Fairy Tale* (Oxford University Press, 2014). She has written widely on myth, in such books as *Stranger Magic: Charmed States and the Arabian Nights.* She is Professor at Birkbeck College, London, and a Fellow of All Souls College, Oxford. She is currently working on a novel set in Cairo. www.marinawarner.com

© 2014 Kehrer Verlag Heidelberg Berlin,
David Parker and authors
First edition, 1500 copies

Words: Marina Warner, Ibrahim al-Koni
Image Processing: Kehrer Design (Patrick Horn)
Design: Kehrer Design (Anja Aronska) and David Parker
Production: Kehrer Design (Andreas Schubert)

Bibliographic information published by the Deutsche Nationalbibliothek
The Deutsche Nationalbibliothek lists this publication in the Deutsche Nationalbibliografie; detailed bibliographic data is available on the Internet at http://dnb.dnb.de.

Printed and bound in Germany
ISBN 978-3-86828-589-5

Kehrer Heidelberg Berlin
www.kehrerverlag.com